Pathways to the Afterlife

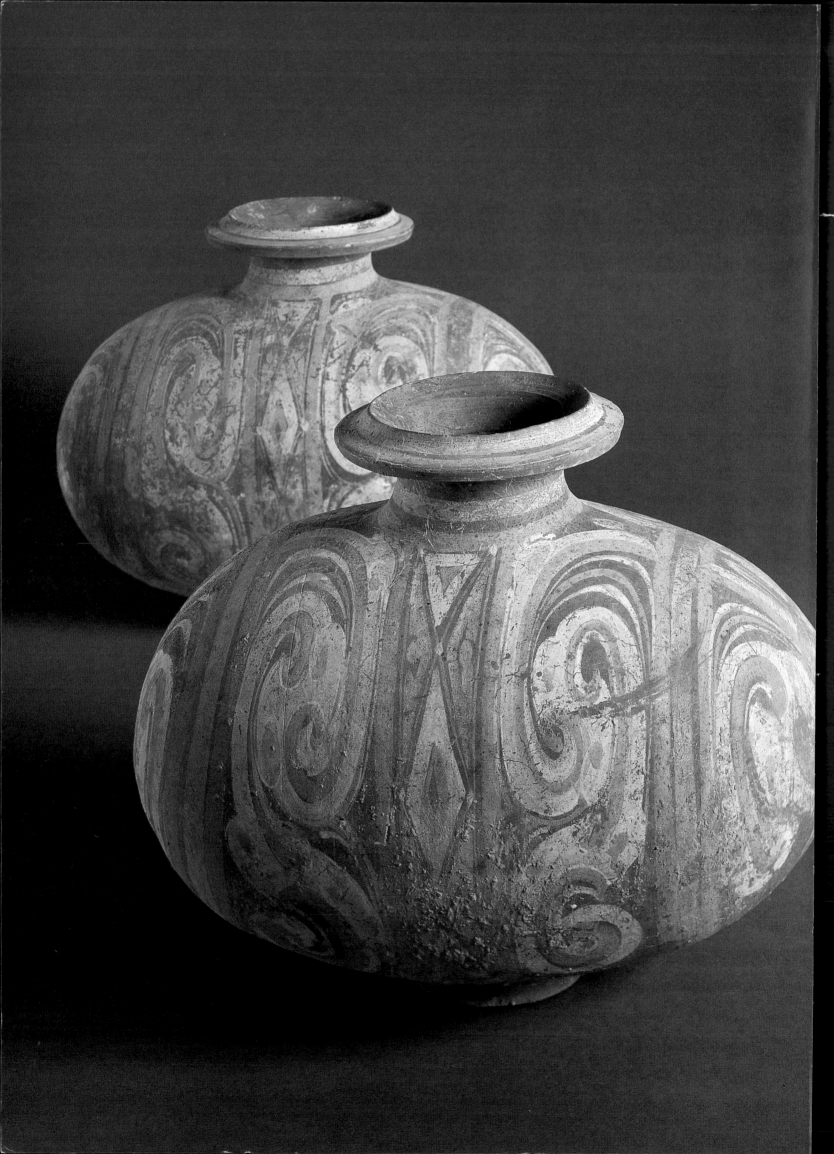

Pathways to the Afterlife

Early Chinese Art

from the Sze Hong Collection

Julia M. White

Ronald Y. Otsuka

Denver Art Museum
in association with
University of Hawaii Press

Copublished by
Denver Art Museum
and
University of Hawaii Press
2840 Kolowalu Street
Honolulu, Hawaii 96822

Edited, designed, and produced by Marquand Books, Inc., Seattle
Photography by Bill O'Connor
Printed and bound in Hong Kong

Cover: Striding duck, Han dynasty, 206 B.C.–A.D. 220 (cat. no. 33)
Back cover: Storage jar, Neolithic, Banshan culture (cat. no. 8)
Frontispiece: Pair of flasks, Western Han, ca. late 3rd–1st century B.C. (cat. no. 30)
Page 10: *Nao*, Shang dynasty, Anyang period, 12th–11th century B.C. (cat. no. 25)

Library of Congress Cataloging-in-Publication Data
White, Julia M.
 Pathways to the Afterlife : early Chinese art from the Sze Hong
Collection / Julia M. White, Ronald Y. Otsuka.
 p. cm.
 ISBN 0-8248-1537-8 (University of Hawaii Press : cloth), —
ISBN 0-8248-1538-6 (University of Hawaii Press : pbk.)
 1. Art, Chinese—To 221 B.C.—Catalogs. 2. Art, Chinese—Ch'in
–Han dynasties, 221 B.C.–220 A.D.—Catalogs. 3. Art, Chinese—Three
kingdoms–Sui dynasty, 220–618—Catalogs. 4. Art, Chinese—T'ang
–Five dynasties, 618–960—Catalogs. 5. King, Warren—Art
collections—Catalogs. 6. King, Shirley—Art collections—Catalogs.
7. Art—Private collections—Colorado—Denver—Catalogs.
I. Otsuka, Ronald Y. II. Denver Art Museum. III. Title.
N7343.2.W55 1993
730'.0931'07478883—dc20 92-38637

Contents

7 Director's Statement

8 Preface and Acknowledgments

10 Chronological Table

11 Map of China

12 Introduction

18 Neolithic Period

46 Shang and Zhou Dynasties

64 Warring States and Han Dynasty

84 Six Dynasties, Tang, and Liao Dynasties

99 Selected Bibliography

102 Index

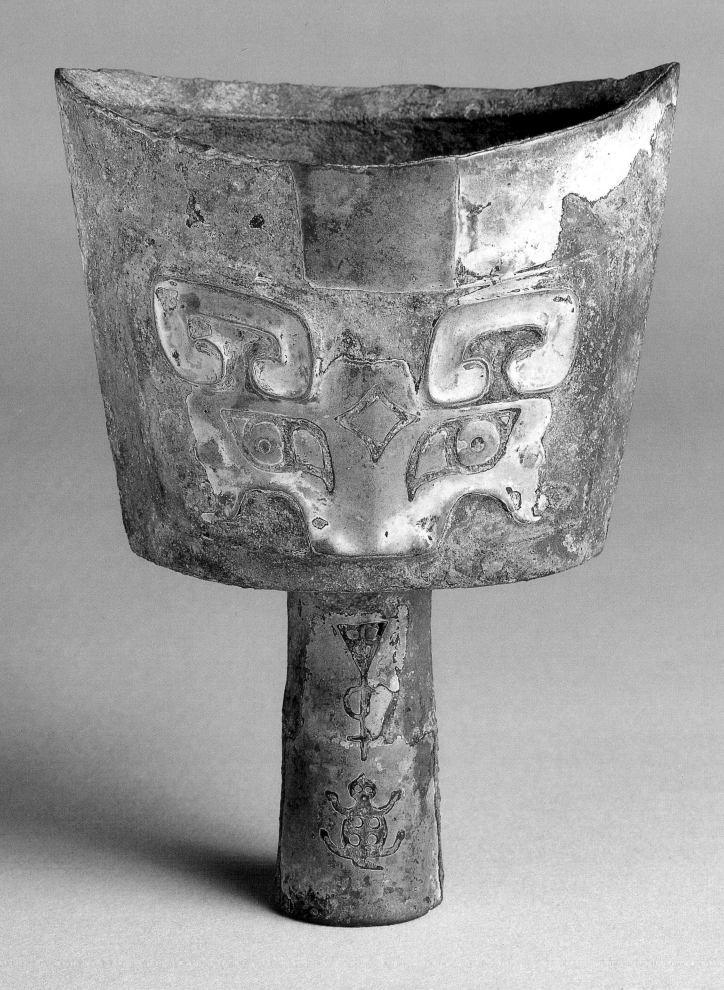

Director's Statement

The Denver Art Museum is proud to present *Pathways to the Afterlife: Early Chinese Art from the Sze Hong Collection* in celebration of the Museum's first one hundred years and in conjunction with the reopening of the Asian galleries. This exhibition is the first to be held in our new gallery devoted exclusively to the Sze Hong collection. It exemplifies the kind of intimate, in-depth, high-quality exhibition that we intend to feature in this space and sets the standard by which we will select and present an ongoing series of exhibitions from the Sze Hong collection.

In featuring the Sze Hong collection in a designated gallery, we recognize the tremendous impact it has had on the Asian collection and its direction during the last six years. The collection reflects the personal taste and collecting interests of its owners, Warren and Shirley King, whose family history in collecting Chinese art reaches back for generations. Their generosity in placing their personal collection at the Denver Art Museum has led to a warm relationship between the King family and the Denver Art Museum staff. Warren's enthusiasm for the beauty of the art and its place in Chinese culture is matched by Shirley's commitment to having the collection displayed in the most splendid setting possible.

As we present this material, much of it never before published, I must extend my thanks to Richard Kimball and Julie Segraves, who introduced the King family to the Denver Art Museum. We are grateful for their initial introduction and continuing support of the relationship between the collectors and the museum staff. The museum received financial assistance from Robert and Helen Silber and from Donald and Nancy Todd to bring the collection to Denver. Members of the Asian Art Association, including its then-president Elizabeth B. Labrot, also played a major role in supporting the transfer of the collection to the museum and continues to develop educational programs around the collection. A. Barry Hirshfeld, chairman of the Board of Trustees at the time of the initial loan, and Julie Smith, chairman of the Collections Committee, worked tirelessly to see that the collection was placed in Denver.

My congratulations to Julia M. White, associate curator of Asian art, and Ronald Y. Otsuka, curator of Asian art, for their contributions to the exhibition and catalogue. The catalogue is the culmination of several years of research in early Chinese art. It stands as a landmark in early ceramics research and should be the basis by which further studies are applied. I would also like to recognize the strong support that the curators received from many staff members, particularly those in the offices of the Registrar, Design, Publications, Photography, and Collections.

Lewis I. Sharp
Director

Preface and Acknowledgments

The Sze Hong collection of early Chinese art is owned by the family of Warren and Shirley King. Their generosity has brought a large and fine collection of Chinese art to the Denver Art Museum on extended loan. We are very pleased to be able to share it with the Denver community and, through this catalogue, with a much larger audience. The selection of exhibited works focuses on the collection's major strengths: early Neolithic ceramics, ritual bronzes of the Shang and Zhou periods, and the tomb ware of the Han and Tang periods. The exhibition (February 6, 1993–January 2, 1994), a celebration of the collectors' vision and dedication, is also part of the activities surrounding the opening of the newly reinstalled galleries of Asian art at the Denver Art Museum.

The concept of this project, exhibition, and catalogue first came into being when discussions concerning the loan of the Sze Hong collection were initiated in 1986 by long-time Denver Art Museum supporters Julie Segraves and Richard Kimball. Knowledgeable, thoughtful collectors in their own right, Julie and Richard provided the initial introductions between museum staff and the collectors. They persevered in supporting the project as the museum and the King family came to terms of agreement for placing this important collection in Denver. It was only through their commitment to the museum that the loan was secured and that cataloguing and presentation of the collection could proceed.

I am grateful to the director of the Denver Art Museum, Lewis I. Sharp, for his encouragement in pursuing publication of the catalogue as well as presentation of the special exhibition. Lewis saw to it that Curator of Asian Art Ronald Y. Otsuka and I received the necessary support to pursue our research and acted with great understanding as difficulties were faced and overcome. I also wish to thank Ronald, who has a keen appreciation for the material and a great ability to work cooperatively. His calm, good-natured manner has proved time and again to be the thread that holds the Asian Art Department and its many projects together.

Without the constant care and support exhibited by our departmental staff the exhibition and catalogue would not have been possible. I am especially grateful to Bj Averitt, long-time museum volunteer, who ably and cheerfully held the fort while I traveled and did research. Volunteer Maureen Ulevich assisted in innumerable ways, including spending many hours doing library research. Thanks also are owed to administrative assistant Ramona Chun who oversaw the photography and the administration of the initial aspects of the project. Administrative assistant Page Shaver contributed to many areas, including preliminary proofing and editing of the manuscript. Suzanne Kotz of Marquand Books superbly managed the editing and proofreading of the text.

Many other museum staff members contributed significantly. Photographer Bill O'Connor ingeniously solved the problems inherent in photographing ceramics and bronzes. Cynthia Nakamura managed the complicated logistics of scheduling, proofing, and record keeping associated with photography. Marlene Chambers, head of the museum department of publications, did a fine job of overseeing the catalogue. L. Anthony Wright, Debra Ashe, and Pamela Taylor of the registrar's office showed great professionalism in safely bringing the collection into the museum as well as in meticulously handling, storing, and caring for the inventory. Exhibition design was creatively executed by the museum design staff headed by Jeremy Hillhouse with Leland Murray acting as chief designer on the project.

Much of the research necessary for this publication involved the use of outside libraries. The Freer Gallery of Art Library, Smithsonian Institution, generously provided much of the resource material for the publication. Librarian Lily Kecskes and her staff were tremendously helpful throughout a long period of research. Emma C. Bunker, research associate at the Denver Art Museum, opened her private library to us and also provided essential editorial support and advice. Her knowledge of early Chinese art and archaeology provided expertise for all aspects of this project. Fred A. Cline, Jr., librarian at the Asian Art Museum of San Francisco, kindly allowed Ron Otsuka access to the fine library under his supervision.

I benefited significantly from a National Endowment for the Arts professional development grant that in 1987 allowed me to travel to Europe in order to study the important Chinese ceramic collections in England, France, Scotland, and Sweden. Without the help, support, guidance, and direction of Professor William Watson, formerly of the British Museum

and the University of London, I could not have begun to learn the intricacies of early ceramic research.

Thanks are owed the many colleagues in museums and private galleries who permitted me to study their collections. Mary Tregear of the Ashmolean Museum kindly spent time with me in her storage area, guiding me through that vast collection of green ware. Shelagh Vainker of the British Museum, Rosemary Scott of the Percival David Foundation, and Louise Hoffman of the Victoria and Albert Museum allowed me access to collections and records that were enormously helpful. Jane Wilkinson and Jennifer Scarce at the Royal Museum of Scotland allowed me to peer into back rooms even while they were under construction. In Stockholm I was most fortunate to be taken under the wing of the very able Mette Siggstedt, who arranged for me to see the vast holdings of Neolithic pottery in the Museum of Far Eastern Antiquities. Her colleague Per-Olow Leijon helped to make my stay in Sweden pleasant and memorable. In Paris, Jean-Paul Desroches at the Musée Guimet spent many hours showing me objects from storage. At the Musée Cernuschi, I was fortunate to have as my escort Vadime Elisseeff. Thanks are also owed Ken and Janet Taylor, John Kent, Lisa Robins, Hervé Pauze, and Oliver Watson, all of whom showed me great hospitality during this research trip.

In 1988 I had the good fortune to receive an Asian Cultural Council Fellowship that allowed me to spend six weeks in China studying early Chinese ceramics. I thank my Chinese colleagues, particularly Wang Xinmin, cultural officer of the People's Republic of China Chicago consular office, who offered me introductions to Chinese museums throughout the country. Jin Feng, chief of the foreign affairs section of the State Administrative Bureau for Museums in Beijing, also provided me with valuable introductions. Wang Yitao, director of the preservation department of the Banpo Museum in Xian, arranged for objects to be brought out from storage to facilitate my research and also introduced me to the museum's delightful staff. Wang Zhijun, vice-president of the Banpo Museum, graciously showed me the galleries and objects from the museum's collection. Zhang Yongxi, vice-curator of the Qinghai Provincial Museum, was extremely helpful during my stay in Xining. He very kindly escorted me to Liuwan and introduced me to Chen Guoxian and Li Szwu at the Liuwan site. Cheng Zheng, associate research fellow of the Shaanxi Traditional Painting Institute, showed me many of his photographs of Neolithic pottery and shared with me his theories regarding early design. Wu Yiru and Zhang Pengchuan from the Gansu Provincial Museum assisted me in exploring their special exhibition at the National Museum of History in Beijing. Yuan Te-hsing, from the National Palace Museum in Taipei, also shared insights into Neolithic pottery design. At the District Museum in Linxia, Ma Long greeted me, and Liang Wenguo escorted me through their holdings. To all these colleagues as well as the administrative staff at the Asian Cultural Council, Richard Lanier, its director, and Sarah Bradley, program associate, I owe a great deal of thanks.

Friends and colleagues in Washington, D.C., particularly David Curry, Becky Morter, and Neil Averitt, provided support and understanding through many phases of research, and I am grateful to them all. Finally a note of thanks to my parents, Walter and Eileen White, for their unfailing support of my endeavors. They were instrumental in opening my eyes to the beauty in the world of art.

Julia M. White
Associate Curator, Asian Art

Chronological Table

NEOLITHIC	ca. 5000–1500 B.C.
PRE-YANGSHAO	
Dadiwan	ca. 5100–4700 B.C.
GANSU YANGSHAO CULTURE	
Banpo Phase	ca. 4800–3300 B.C.
Miaodigou Phase	ca. 3700–3000 B.C.
Majiayao Phase	ca. 3290–2880 B.C.
Shilingxia	
Yanerwan	
Xipogua	
Wangbaobao	
Banshan Phase	ca. 2655–2330 B.C.
Machang Phase	ca. 2330–2055 B.C.
QIJIA CULTURE	ca. 2050–1900 B.C.
SIBA CULTURE	ca. 1950–1500 B.C.
XINDIAN CULTURE	ca. 1500–after 1000 B.C.
Tangwang Group	
Zhangjiaju Group	
Sishiding Group	
Xindian Group	
SHANG DYNASTY	ca. 1500–1050 B.C.
ZHOU DYNASTY	ca. 1050–221 B.C.
Western Zhou	ca. 1050–771 B.C.
Eastern Zhou	ca. 770–221 B.C.
Spring and Autumn	770–475 B.C.
Warring States	475–221 B.C.
QIN DYNASTY	221–206 B.C.
HAN DYNASTY	206 B.C.–A.D. 220
Western Han	206 B.C.–A.D. 9
Eastern Han	A.D. 25–220
SIX DYNASTIES	220–589
Three Kingdoms (Wu) Period	220–265
Western Jin Dynasty	265–316
Eastern Jin Dynasty	317–420
Southern and Northern Dynasties	420–589
SUI DYNASTY	581–618
TANG DYNASTY	618–907
FIVE DYNASTIES	907–960
LIAO DYNASTY	907–1125
SONG DYNASTY	960–1279
Northern Song Dynasty	960–1127
Southern Song Dynasty	1127–1279

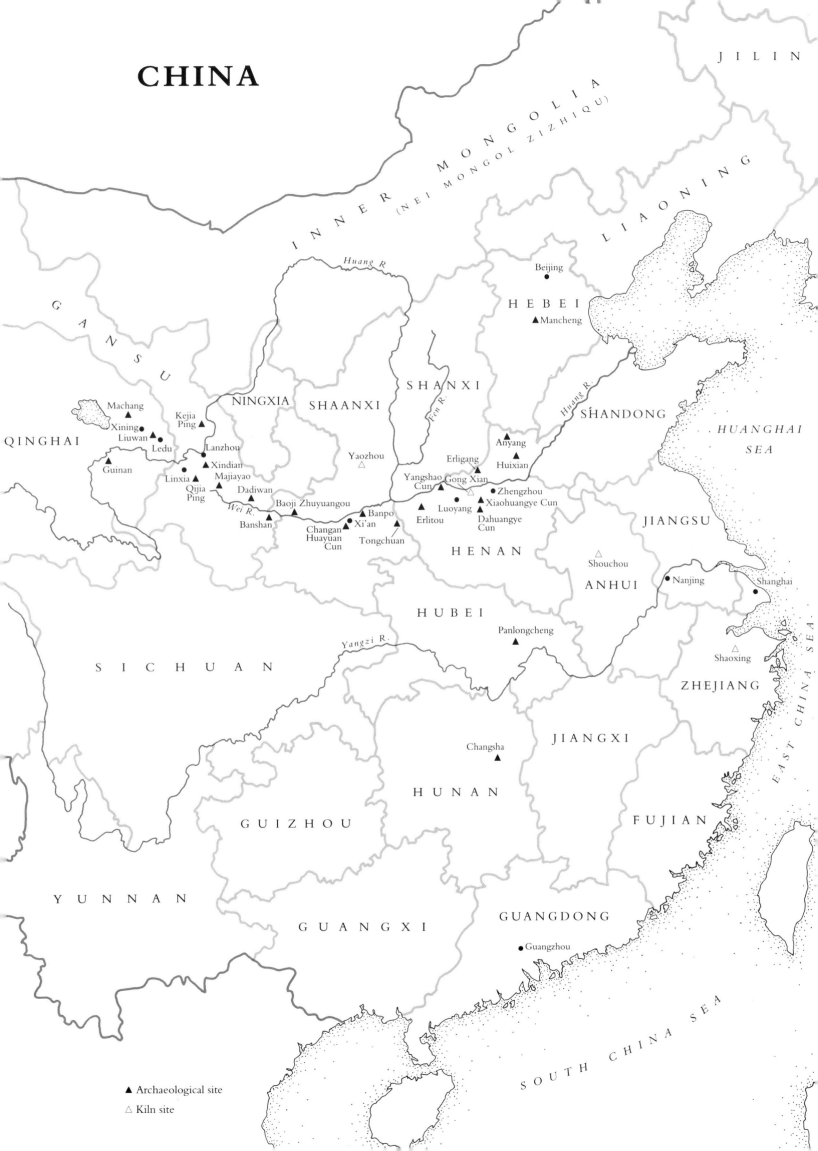

Introduction

The Sze Hong collection provides a unique glimpse into the origins of Chinese art, design, and decoration. Examination of the forty-three vessels presented here permits us to trace Chinese art from its beginnings at the hands of the Neolithic potter, through its development by the Shang and Zhou bronze caster, up to the creation of burial objects in the Han and Tang periods. This select group of objects, although not a comprehensive study of early Chinese art or the Sze Hong collection, tells of beauty and ritual in early China.

The majority of these vessels were employed in ceremonial observances of their time. Some, such as the Shang and Zhou bronzes, were made for specific functions within ritual. Others, like many of the Neolithic jars, were apparently used for everyday storage before being entombed as attendant burial objects. The specific function of many Neolithic objects is not known but is assumed because of their pivotal role in burial. Central China's later emphasis on solemn celebrations in every aspect of life reinforces the likelihood that these burial pieces were a part of a larger ritual. Similarly, Han and Tang objects created for burial clearly played a major role in ritual practices. Han and Tang objects of practical use might also have had a ritual function, for they too were placed in the tomb to accompany the deceased in the afterlife.

Neolithic Period

As early as China's Neolithic period potters were transforming plain clay into objects decorated with highly systematic patterns. Although in some respects quite primitive, Neolithic society clearly had an appreciation of the beauty of symmetrical and harmonious designs. Perhaps by examining the implications of these designs, we will find a deeper meaning to the use of the ceramics they adorn. But whatever the meaning, Neolithic art, as demonstrated by the pottery in this exhibition, is purposeful and elegant.

Gansu Yangshao Tradition

Designs, materials, and method of manufacture of Neolithic pottery in China remain constant for the cultural group that grew out of the culture known as Yangshao.[1] The pottery of this culture is hand-built, buff to brown in color, and decorated with painted designs. A few examples from the central Yangshao tradition (fig. 1b and cat. no. 3) are present in the Sze Hong collection, but most of its Neolithic material is from cultural groups that developed slightly later and to the west, and known as the Gansu Yangshao tradition. The term applies to pottery that retains the same characteristics of manufacture as seen in the Yangshao culture but demonstrates a different painted design vocabulary. It seems certain that this western branch is a direct offshoot of the central Huang (Yellow) River valley traditions observed most clearly at Banpo. The chronology of dated objects from this western culture indicates a cultural migration from east to west.

The current dating of these cultures is based directly on evidence supplied by archaeologists over the last thirty-five years. Neolithic material that has been dated on the basis of scientific excavation aids significantly in the assignment of dates to objects of unknown provenance, and insofar as possible, the Sze Hong material in the catalogue has been compared with excavated articles, utilizing the reports and documents of numerous authorities. Because shapes and designs within region and culture are so distinct in the Gansu Yangshao tradition, physical similarities make possible the dating of the Sze Hong Neolithic material. Examples presented here range from the beginning of the western Yangshao tradition, in the form of the early Banpo-derived type (cat. nos. 1 and 3), to the central core of Gansu Yangshao culture with its progressive phases of Majiayao, Banshan, and Machang periods (cat. nos. 4–12), followed by the later cultures of Qijia (cat. no. 13) and Xindian (cat. nos. 14 and 15).

Archaeological methods employed in China have advanced considerably within the last fifty years; entire new cultures have been discovered, and horizon dates continue to be expanded. The archaeologist K. C. Chang has described how these cultures developed and spread from a few regional communities into an expanded and interconnected Neolithic culture that formed the basis for historical China.[2] The systematic excavation of many sites in the Gansu, Qinghai, and Xinjiang regions has greatly increased our understanding of the distribution of cultures from the central Huang River valley westward.

With these advances in archaeology, we might expect significant changes in our understanding of the respective cultures. During the last thirty years the discovery

of new information has led leading archaeologists to change their views regarding entire cultural sequences. For example, the dating of the Xindian culture proposed by An Zhimin in 1956 was challenged in 1978 by Yan Wenming (see cat. no. 14),[3] who used data obtained through scientifically controlled excavations and additional site opportunities to offer a refined sequence that recast the dating of the Xindian culture.

Neolithic cultural development can be traced through the distinct designs of each cultural phase. Distinctions of dating may be made based on design differences between central Yangshao and Gansu Yangshao, between various phases of Gansu Yangshao cultures, and between Gansu Yangshao and its later offshoots such as the Qijia and Xindian cultures. For example, a particular gourd pattern (see cat. no. 5) has been proven through archaeological findings to belong to the Banshan phase of the Gansu Yangshao tradition.[4] It has been further recognized that this pattern varies in width between the early, middle, and late years of the Banshan phase.[5]

It would be erroneous to assume that any of these cultures, or cultural phases for that matter, stand alone and independent of one another. The degree of cultural overlap and influence is still not well understood, but it is clear that the central Yangshao culture, found initially along the Weishui and Fen rivers, did influence the developments at the Banshan and Machang sites.

All evidence points to the necessity of flexibility when assigning a cultural or period date to any object that shares characteristics with more than one culture. A good example is the overlap found in the central Yangshao Banpo culture and the rising Majiayao culture. A beautifully painted water carrier (cat. no. 1) reflects the Banpo cultural phase and is the earliest amphora shape found in the Gansu Yangshao tradition. The subject of the painting is reminiscent of the animallike designs found on Banpo objects, while the stylistic

execution of the painting is close to the finest of the Majiayao phase. The amphora belongs in two camps, Banpo and Majiayao. In all likelihood it is a transitional ware that exemplifies the best of both phases.

Highly distinctive patterns that developed in one phase appear to have been acquired, altered, and then wholly adopted by another phase. We see this in the same amphora, which shows the adoption of the style of late Banpo or early Majiayao decoration. Another example can be seen in a large, finely executed storage jar (cat. no. 8). Here is a rare appearance of a typically Machang design, a sticklike figure motif, on what is otherwise a vessel of Banshan characteristics. It is quite unusual to find this type of decoration on anything but Machang-phase wares, but the shape, style of painting, and high-gloss finish are so consistent with what we know of Banshan-phase wares that it must be assigned to that culture.

Although it is tempting to assume that with cultural progression comes sophistication in design, manufacture, and execution, the archaeological evidence clearly points to a more random rise and fall in the quality of production than might be assumed by an early or late date. The best example of this in Neolithic ware comes from the relative awkwardness apparent in Machang wares (cat. nos. 9–12) when compared to the significantly earlier Banshan wares (cat. nos. 5–8), which show considerably more care in manufacture, design, and execution than the later wares.

Materials and Methods

An offshoot of the central Yangshao painted-pottery tradition, the pottery manufacture of the Gansu Yangshao cultures employed a tempered clay. Apparently local, the clay varies only slightly in color from area to area within a broad region; it usually fired out to a buff or occasionally a slightly reddish brown color.

Some evidence suggests that in the later phases of the Xindian and Qijia cultures

the potter may have utilized the wheel or mold forms (see cat. no. 14). Potters of the early cultural phases, however, built the main body of the vessel exclusively by the coil technique. In this simple and straightforward process, snakes of clay were rolled out and fitted together to form the basic shape. Tools and the human hand were then used to flatten the walls of the vessel to the desired consistency, while handles, neck, and, in some cases, whole sections of the body were luted together.

To decorate the vessel, a mineral-based slip was baked onto the surface in a kiln heated to between 800 and 1020 degrees C. Not a true glaze, this slip paint acted only as decoration since it did not protect the vessel or make it any more durable.

Function

The specific function of Neolithic vessels is open to speculation, although some broad conclusions can be reached. When J. Gunnar Andersson first made his discoveries of the western branch of the Yangshao culture in the early part of this century, he was concerned primarily with burial sites and so concluded that the vessels were made for interment.[6] More recent excavations have dispelled this theory and raise the issue of what, if anything, was made solely for funerary use. Most vessel types from all cultural phases have been found in habitation as well as burial sites. It seems clear, therefore, that vessels had a function within the living society even in cases where the vessel was also used to inter remains, as at Banpo.[7] A large bowl (cat. no. 3) may represent those used as lids in this kind of burial, but at least initially, such bowls most likely had a practical, utilitarian role.

Many of the pottery vessels from all phases of the Gansu Yangshao tradition are large jars that were presumably used for storage (see cat. no. 6). A low firing temperature created a relatively porous body that made the vessel suitable for storing only dry products, most probably grain. Smaller vessels may have been cups for storage or drinking, although liquid would

have soon seeped through the porous clay. These cuplike forms appear quite frequently in the Machang period, but the most appealing and graceful forms are found in the later periods of Qijia (cat. no. 13) and Xindian (cat. no. 15). Amphorae (cat. no. 1 and fig. 1b) were specifically designed to carry water and acted very much like canteens.

The function of a vessel helped to determine its shape, which was accentuated by designs covering its surface. Most large jars are painted only across the top two-thirds, with the lower portion left undecorated (see cat. nos. 5–11). The practice seems to have resulted from a functional aspect of the jar (see cat. no. 6). The broad shoulder was decorated with a continuous line moving freely across the surface, as though the vessel would be seen from the top (see cat. no. 6, top view). In the early stages of Gansu Yangshao pottery (Majiayao and Banshan), decoration on large storage jars was applied directly to the jar's body (see cat. nos. 2 and 5–8), while in later periods, particularly the Liuwan period of the Machang phase, a red wash was applied to the body before the black mineral pigment was painted onto the vessel (see cat. nos. 10–12).

Design and Meaning

Records do not exist to tell us anything definite about the meaning of the painted designs on these vessels. Some interpretations have suggested that certain designs are frogs, toads, or "tufted zoomorphs" (see cat. no. 8).[8] But such interpretations cannot be confirmed, and it seems unlikely that a twentieth-century view would coincide with Neolithic intent. Even if we choose to see a toad or zoomorphic image represented on a vessel, we are still very far from understanding the reason for its appearance on a storage vessel. Perhaps further study will indicate a reason and point to either pictorial, shamanistic, or linguistic meaning. Markings on the lower, undecorated portions of large storage jars (see cat. nos. 10 and 11) have been more thoroughly analyzed and appear to

represent a writing system or to communicate a specific meaning.

Two important instances show that designs developing in the Neolithic period were carried through into the era of historical China, thus confirming the impact of early designs on later Chinese art. The first example is a spiral pattern seen commonly among Xindian-culture artifacts and referred to as a *leiwen* pattern in later bronze-culture terminology. The nascent stage of this pattern can be discerned in a large Neolithic storage jar (cat. no. 14). It appears again as a primary design element in the decoration of Shang ritual bronzes (see cat. nos. 16–18 and 22) and is prevalent in the great majority of early Zhou bronzes.

A second example of the influence of early decoration and techniques on later design can be seen in Neolithic storage jars of the Liuwan type (see cat. no. 12). Small, round indentations pressed into the clay body clearly held some kind of inlaid material, probably bone disks, which have been found adjacent to vessels of this type at Liuwan.[9] Such jars may display the first examples of Chinese inlay, a technique that contributed much to the bronze caster's art during the Shang, Zhou, and Warring States periods.

Later Pottery

The foundation of ceramic production built by the Neolithic people profoundly affected the success of later pottery manufacture. Ceramics have been highly valued and extensively produced throughout China's long history, and Chinese ceramic techniques have been far in advance of any used elsewhere until well into recent times.

Over the years the primary function or use of ceramics gradually changed from at least partly ritual to completely everyday. From about the end of the Bronze Age, however, specific ceramic items were produced solely as burial items. Fine examples of pottery made for burial from the late Zhou through the Tang dynasty demonstrate the techni-

cal and aesthetic advances that eventually led to the production of the beautiful hard-glazed wares of the Song dynasty.

This catalogue examines a few leading examples of ceramic vessels, primarily burial pieces, that were produced between the end of the Bronze Age and the beginning of the Song period. These wares are distributed over a much greater area than the Neolithic material examined above. The major kiln sites from the Warring States period onward are roughly divided between north and south and along the eastern portion of the country, unlike the east-west division in northern China that was evident in the Neolithic period. Tomb and kiln findings aid significantly in dating these objects and record the rise and fall of styles, techniques, and innovations.

Ritual application of these ceramics is apparent from the materials used to make them and from the quantity found in tombs. The fragility of the materials, not their rarity, identifies the ritual purposes of such ceramics. The fragile pigments of a large *hu* (cat. no. 29), for example, are easily disturbed by the slightest contact and could not have endured the handling involved in everyday use. Although the *hu*'s shape might have been derived from a usable Han dynasty bronze, its surface decoration is impractical. In addition, this vessel is marked in several places by an organic growth that could only be the result of prolonged burial.

Other examples of this same kind of painted decoration can be seen in a pair of flasks, or *yadanhu* (cat. no. 30). Ceramics of this shape and construction have been found only in tombs in eastern China and thus have a ritual association.

Burial items often have a slightly impractical quality that helps to identify them as objects intended for ritual use. A good example is a Six Dynasties ewer (cat. no. 37). This vessel, probably from a southern kiln, has a spout that is too narrow for any practical purpose. As a beautiful, perhaps meaningful object for the deceased, however, it probably played an important role. The ewer's decoration and

finish are very fine, but a serious firing crack on its base makes it totally impractical. That this was not an isolated mishap in construction and firing is suggested by the numerous ewers of similar decoration that have been found in burial sites.[10]

The production of low-fired earthenware vessels with lead flux glaze was common by Han times and continued into the Tang and Liao periods. The glaze gave the objects the appearance of a valuable and prized object to be carried by the deceased into the afterlife. A hill jar (cat. no. 31) and an incense burner (fig. 32a) are examples of this type of soft-bodied ware. Both were very likely intended to resemble bronze objects, which were too costly and precious to be left in all but royal tombs. The soft body, however, made the wares extremely fragile and inadequate for extensive use. To compound the problem, the glaze adhered poorly to the vessel, which further discouraged repeated handling.

Durability of tomb ceramics improved in the Tang period owing to technical advances in ceramic production. In addition to the soft-bodied wares like those of the Han period, a much harder-bodied ware was also produced (see cat. no. 38). The more sophisticated lead flux used to glaze Tang ceramics achieved better adhesion than that used on Han vessels. In addition, the translucence of the glaze gives the objects a more refined appearance. A white-bodied bowl (cat. no. 39), with its near-porcelain body showing through, takes even greater advantage of the clear glaze. Perhaps this type of vessel was admired and used before finding a place as a burial object.

Practical wares from the dynastic periods on may have ended up as burial items, but their strength and durability indicate that they were intended at least initially for use. A large, gray Warring States storage jar (cat. no. 26) is a relatively high-fired stoneware that seems nearly indestructible. Production of this type of ware was limited to the provinces of Anhui and Zhejiang.[11]

From the east-central part of the country a different type of practical ware emerged as early as the Western Han period. A jar, sometimes called a *pou* (cat. no. 28), has some resemblance to bronze objects. Its stoneware body and thin green glaze more closely align it with the later proto-*yue* forms of the Jin period. Large wine storage vessels from the Han period (cat. no. 35) demonstrate the beginnings of hard-bodied glazed ware from the south. Regional preference in surface decoration is evident in the lyrical quality of the linear designs running across the shoulder of this vessel.

The direction for ceramic production established in Neolithic times was brilliantly followed in later periods with advances in technique. Whether vessels were intended for ritual or practical use, it seems clear that, from the beginning, Chinese potters attempted to meet society's demand for beautiful objects of high quality.

Shang and Zhou Dynasties

The historical period in China is marked by the formation of a governing structure whose legitimacy, according to belief, was mandated by heaven. If the ruler became weak or corrupt, heaven might withdraw its favor and widespread disaster would result. It is not surprising to find numerous ritual objects within the artistic legacy of this period. Chief among them are finely crafted bronze vessels created for use in ritual sacrifice. Examples from the Sze Hong collection illustrate many principal vessel types and decorative styles prevalent during the period. From technique to shape and decoration, each aspect of bronze-making art helps to further refine our understanding of this early culture. In many instances inscriptions on the vessels refer to clan members, indicating societal relationships that existed as a part of ritual. Through comparison with excavated objects, the inscriptions also allow us to date many bronzes.

Techniques and Materials

Bronze making in Shang China involved a piece-mold process in which surface decoration was carved into a clay mold and used, together with a clay model of the desired object, in the original cast. The molds were made in sections that fit tightly together, although seam marks are seen even on finely executed bronzes. An early bronze, a *jue* (cat. no. 16), shows a fine linear design and evidence of a seam at its base. In later bronzes from the Zhou dynasty (see cat. no. 24), decoration is considerably more complex, but the casting process is the same. In some cases, the seam lines are incorporated into the surface decoration (see cat. no. 23).

Relationship to Pottery

The influence of Neolithic pottery on bronze manufacture was twofold. By learning to control the temperature during firing and by developing a fine-grained clay, early potters perfected the skills and techniques that would enable later bronze casters to make extremely hard and durable ceramic molds.[12] Not only were the skills of Neolithic potters employed by bronze casters, but many ceramic vessels themselves served as models for later bronze forms.

It is unclear, however, to what extent the ceramic pieces served as direct prototypes. Further, it should be noted that some early bronzes seem to have inspired later ceramic works. Early pottery forms of *li ding* similar to bronze *li ding* (see cat. no. 22) are found in the Neolithic as well as the Shang and Zhou periods.[13] *Hu* and *fang ding* ceramic examples similar to bronze examples (see cat. nos. 20 and 23) have been found at early Shang sites at Zhengzhou. Early bronze forms like the *jue* (see cat. no. 16), however, seem not to have had a ceramic prototype; rather, the ceramic form is an imitator of the bronze.[14]

Function

Bronze shapes developed and changed according to the specific needs of Shang

and Zhou rituals. *Jue* and *jiao* (see cat. nos. 16 and 17) have similar shapes, with a cup resting on three high, slender legs. During the Shang such objects had great value as wine vessels, but as wine drinking was discouraged during the Zhou period, the need for such vessels decreased and they soon disappeared. Zhou rituals emphasized offerings of food, which may explain the rise in popularity of *ding* during the period. *Li ding* (cat. no. 22), *fang ding* (cat. no. 23), and *gui* (cat. no. 24) are examples of food containers used in ritual offerings.

Of the ten Shang and Zhou bronzes illustrated in this catalogue, eight have inscriptions. Such inscriptions often provide insights into the ritual nature of the vessels as well as aid in dating and in understanding societal structure. Many inscriptions are highly pictographic, as illustrated by the turtle image seen on the shank of a bell (cat. no. 25). Some dedicatory inscriptions (see cat. no. 17) indicate that a vessel was made to honor a particular member of a clan. Some even give further indications that the vessel is part of a set. The object's sacrificial function and maker as well as the recipient are mentioned in the inscription on a Western Zhou *you* (cat. no. 21). A similar inscription can be found on an eleventh-century B.C. *fang ding* (cat. no. 23). Inscriptions found on a *gu* (cat. no. 18) and on a *zun* (cat. no. 19) resemble inscriptions found on objects with established dates and thus are helpful indicators of the probable dates of these two vessels.[15]

It seems highly probable that surface decorations have a meaningful connection to a vessel's intended use, but those meanings remain unclear. Commonly seen patterns of *leiwen* (spirals) and *taotie* (animal masks) have been observed and well documented from the Shang through the Zhou periods, but their significance is no better understood than that of the patterns seen on earlier Neolithic ceramics.

Later Bronzes

Although ancestral rituals continued to be performed in the Han period, the size and quantity of bronzes diminished from those made for Zhou royal houses. During the Han dynasty, bronze vessels lost much of their ritual significance and began to play a much greater role in everyday life.[16] The massive ritual *ding*s of the Zhou period gave way to more lyrical and elegant forms.

Although bronze forms changed in the Han, decorations that had developed in the Neolithic period persisted. A pair of Han dynasty *hu* (cat. no. 35) displays the *taotie* mask and *leiwen* pattern on their handles. These designs appeared earlier on Shang-period bronzes (see cat. nos. 17–20). The *leiwen* pattern, first noted on Neolithic pottery, continued as an important design element in Shang bronzes (see cat. nos. 16–18 and 22).

A *li ding* (cat. no. 22) shows the *taotie* in its full maturity at the end of the Shang. From this point on, the use of the *taotie* motif as the dominant decoration decreased. This can be seen in an early Zhou bronze *fang ding* (cat. no. 23), where the *taotie* has moved from the central panel to a minor position at the top of the legs. By the late Zhou and early Han, the motif had become a merely decorative element, as seen on the handles of a *hu* (cat. no. 34).

Han dynasty bronze manufacturers developed many new shapes as vessels increasingly became objects of everyday use. Two new shapes that are elegantly represented in the Sze Hong collection are the *boshanlu* (cat. no. 32) and the duck-shaped lamp (cat. no. 33). Both are largely devoid of the imagery used on Shang and Zhou ritual vessels, and both probably originated in the Han period.

The *boshanlu* reflects an attempt to recreate in miniature one of the magic mountains of Daoist lore that served as a dwelling place for venerated immortals and sages. The illusion would have been carried further by the burning incense

that emanated from the *boshanlu*, its smoke resembling celestial mists clinging to the summit. The duck-shaped lamp represents a far more humorous approach and demonstrates the delight that Han craftsmen took in creating playful forms.

Fanciful vessels such as these were intended to embellish the homes of the wealthy and to charm their occupants. Like many Neolithic storage jars, however, Han vessels were frequently destined for a ritual end as they accompanied their owners to the grave. —J.M.W.

Notes

1. J. Gunnar Andersson coined the term Yangshao when, in 1921, he made the first discovery of the remains of a painted pottery culture in central China at the site of Yangshao village. Yangshao thus became the name of painted pottery culture in Neolithic China even though the finds from Yangshao village are no longer considered to be of the same culture that carry this name. The other Neolithic culture that arose at a slightly later date is known as Longshan; its sites are found primarily along the east coast of northern China.

2. K. C. Chang, *The Archaeology of Ancient China*, 4th ed. (New Haven: Yale University Press, 1986), pp. 234–94.

3. An Zhimin, "Gansu yuangu wenhua jiqi you guan de jige wenti" (Several questions regarding Gansu's ancient culture), *Kaogu tongxun*, 1956, no. 6, pp. 9–19; and Yan Wenming, "Gansu caitao de yuanliu" (The origins and development of Gansu painted pottery), *Wenwu*, 1978, no. 10, pp. 73.

4. *Gansu caitao* (Gansu painted pottery) (Beijing: Wenwu Press, 1984), no. 70.

5. Cultural Work Team of Gansu Provincial Museum, "Gansu Lanzhou Jiaojiazhuang he Shilidian de Banshan taoji" (Banshan pottery from Jiaojiazhuang and Shilidian, Lanzhou, Gansu), *Kaogu*, 1980, no. 1, pp. 7–10.

6. J. Gunnar Andersson, *Children of the Yellow Earth* (London: Kegan Paul, Trench and Trubner, 1934).

7. Banpo site has yielded a number of vessels containing the skeletal remains of children, found within the village complex. See Wang Zhijun et al., *Banpo yishi* (Banpo site) (Xian: Shaanxi Renmin Meishu Press, 1987), n.p.

8. Clarence F. Shangraw, *Origins of Chinese Ceramics* (New York: China House Gallery, China Institute in America, 1978), p. 29. The phrase "tufted zoomorphs" comes from Denise Patry Leidy in "Tufted Zoomorphs: Figural Images in Machang Ceramics," *Journal of the Museum of Fine Arts, Boston* 1 (1989), pp. 23–30. See also cat. no. 8, below.

9. Archaeological Team, CPAM of Qinghai Province and Institute of Archaeology, CASS, *Qinghai Liuwan*, vol. 2 (Beijing: Wenwu Press), pp. 63–66. See also cat. no. 12, below.

10. Annette Juliano, *Art of the Six Dynasties: Centuries of Change and Innovation* (New York: China Institute in America, 1975), p. 30.

11. Walter Hochstader, "Pottery and Stonewares of Shang, Chou and Han," *Bulletin of the Museum of Far Eastern Antiquities* 24 (1952), p. 100.

12. High-fired, nonporous ceramics were in production at least by the beginning of the Shang period. See An Chin-huai, "The Shang City at Cheng-chou and related problems," in *Studies of Shang Archaeology* (New Haven: Yale University Press, 1986), pp. 15–48. An discusses the findings from Zhengzhou, noting that ceramic workshops produced firings for both clay-textured and sand-tempered pottery (p. 44). Neolithic evidence would suggest that the techniques were known even earlier than the Shang period.

13. See Chang, *The Archaeology of Ancient China*, pp. 368–408.

14. Jessica Rawson and Emma Bunker, *Ancient Chinese and Ordos Bronzes* (Hong Kong: Oriental Ceramic Society of Hong Kong and Urban Council of Hong Kong, 1990), p. 64. Findings of ceramic *jue* at Erlitou are thought to be imitations of metalwork.

15. Jessica Rawson, *Western Zhou Ritual Bronzes from the Arthur M. Sackler Collections*, vol. 2A of *Ancient Chinese Bronzes from the Arthur M. Sackler Collections* (Washington, D.C., and Cambridge, Mass.: Arthur M. Sackler Foundation and Arthur M. Sackler Museum, Harvard University, 1990), pp. 96–98; and Robert W. Bagley, *Shang Ritual Bronzes in the Arthur M. Sackler Collection*, vol. 1 of *Ancient Chinese Bronzes in the Arthur M. Sackler Collections* (1987), pp. 310–11, no. 50.

16. Wang Zhongshu, *Han Civilization*, trans. by K. C. Chang et al. (New Haven: Yale University Press, 1982), pp. 100–21.

Neolithic Period

1. Amphora

Earthenware with mineral pigments
Neolithic, late Banpo phase of central
Yangshao culture, or early Majiayao of
western Yangshao tradition
H: 11 1/2 in. W: 6 1/2 in. D: 4 in.
456.1987

This graceful conical water container with
pointed bottom, tall neck, and flaring lip
is decorated in black slip paint that stands
out dramatically against the fine-grained,
buff-colored body. Like most Gansu-
Yangshao Neolithic pottery, this amphora
was coil-built, then smoothed and paddled
to achieve a thin wall of clay. Two loop
handles were luted onto either side.[1] The
vessel was fired at the relatively low tem-
perature of about 1000 degrees C.[2] Its sur-
face is painted in black mineral pigment
that has been burnished with a fine stone,
creating a hard, shiny surface.

The long neck, flared mouth, and
square shoulder of this amphora are con-
sistent with the profiles of other amphorae
of the late Banpo phase of central Yangshao
culture.[3] The flowing, horizontal pattern-
ing, however, is similar to early Majiayao
pieces found in Qinghai and Gansu,[4] indi-
cating an overlap of central Yangshao
Banpo style with the beginnings of Majia-
yao cultural development.[5] This amphora
may be considered a pivotal object in the
coming-together of the two cultural
phases.

The decoration is similar to the other
well-known painted amphora from
Gansu[6] in that the entire surface of the
vessel, other than the bottom point, is
covered with a finely executed painted
pattern that appears to have been created
with a brush. The Sze Hong vessel

design, with its vertical lines and limblike
protrusions on either side of the central
design, takes on an anthropomorphic
dimension.[7] Examples of design develop-
ment in Yangshao culture suggest that this
motif may have sprung from an earlier,
more realistic pictographic design associ-
ated with central Yangshao tradition.[8]

Equally appealing in terms of the qual-
ity of line is a fine, small rounded jar of
the Majiayao culture (fig. 1a). Here the
fluctuating design elegantly follows the
body of the vessel, incorporating thicker
broad lines for a horizontal banding effect.

Although amphorae with painted
designs are rare, the shape is common in
Neolithic ceramics. Two other examples

may be seen in the Sze Hong collection.[9]
The cord-marked vessel illustrated here
(fig. 1b) is an unpainted amphora with
a rough surface and a type of profile that
is decidedly more prevalent in the central
Yangshao tradition.[10] This amphora has
a rounded, straight lip and a slightly con-
stricted neck; it gradually widens to a full
body at midpoint, then tapers to a sharply
pointed base. Chinese historians describe
this water-carrying vessel as a canteen.
The vessel's center of gravity makes it
self-righting—that is, when it was placed
in water, it would tip over until filled,
then right itself, demonstrating the pot-
ter's sophisticated understanding of
mechanical advantage.[11] —J.M.W.

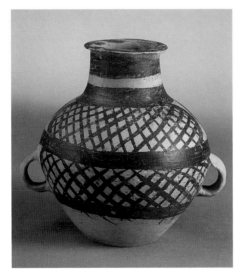

1a. **Jar**

Earthenware with mineral pigments
Neolithic, Majiayao phase of Yangshao
culture
H: 6 1/4 in. D: 6 1/2 in.
187.1989

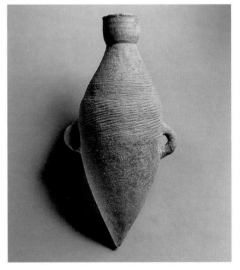

1b. **Amphora**

Earthenware, cord-marked
Neolithic, central Yangshao type,
possibly of the Shijia phase
H: 12 3/4 in. W: 6 1/4 in. D: 4 1/4 in.
457.1987

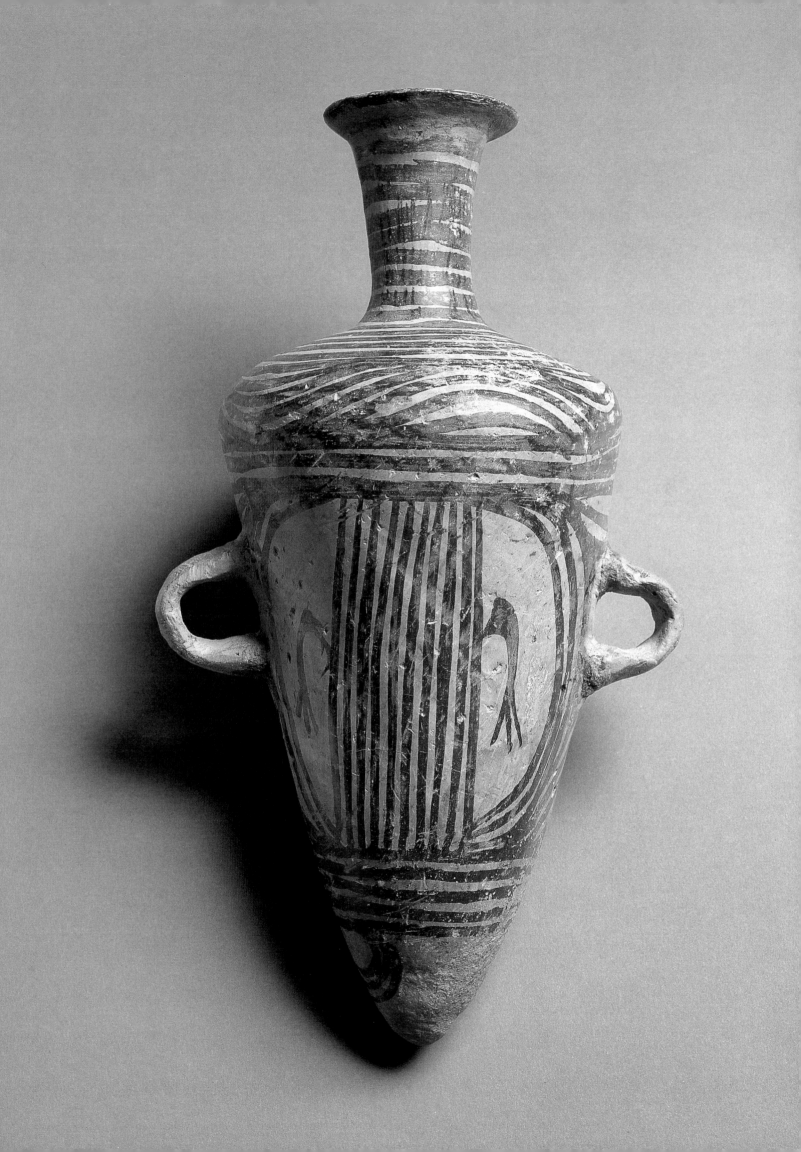

2. Jar

Earthenware with black and white
mineral pigments
Neolithic, Majiayao phase of western
Yangshao culture
H: 6 3/4 in. D: 5 5/8 in.
99.1990

This small, thin-walled, coil-built jar with
flared lip, of a fine-grained, buff-colored
clay, may have been used as a cup or small
storage jar. The low waist, sharply and
precisely angled, tapers at the top to a
constricted neck and at the bottom to a
narrow, flat, unfooted base.[12] The vessel's
angularity is complemented by the triangu-
lar pattern in the body and neck, designs
painted in black and white pigments.

Majiayao-phase pottery, remarkable for
its elegantly painted surfaces, frequently
displays a strong visual repertory that is
perhaps prescient to the calligraphic tradi-
tions of historical China. The black and
white painting that decorates the vessel
employs flowing line and negative space
in a sophisticated treatment worthy of
artistry. The white pigment, a silica base,
is unusual but has precedent in the west-
ern Yangshao tradition.[13] The white
pigment acts as an accent to an already
dynamic design that appears in a variety
of mutations on large and small vessels of
the Majiayao phase.[14] —J.M.W.

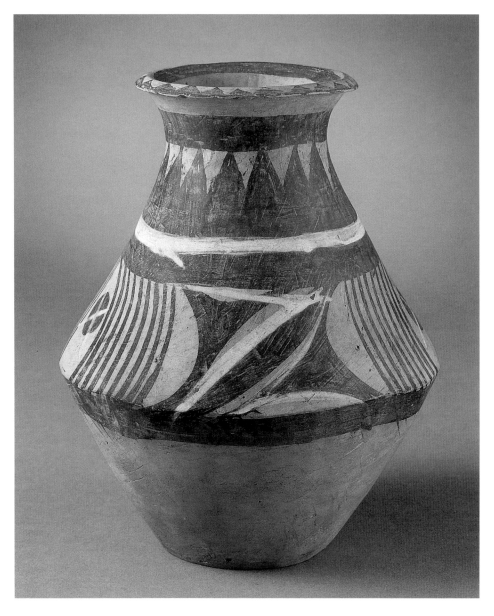

3. Bowl

Earthenware, reddish slip, texture
of woven-mat pattern on bottom
Neolithic, Banpo phase of Yangshao
culture
H: 6 in. D: 12 in.
621.1987

Large and finely potted, this round-bottomed bowl with gently sloping shoulders, even body, and slightly inward-turning lip, exemplifies the simple elegance found in Banpo-phase ceramics.[15] The body of the bowl is a rich reddish brown; its outer lip is covered in a deeper-toned slip. The bowl's rounded bottom is incised with a fine circular mark that encloses a woven-mat pattern across the whole. The pattern, irregular and overlapping in some areas, was probably impressed into the still-soft clay body as it was being finished on a woven mat.

The woven pattern offers an important clue in tracing the development of basketry and also helps define the agricultural status of society at that time.[16] It is impossible, however, to determine if the marking was an intentional decorative motif or an accident of manufacture that was simply accepted as a part of the process.

The rounded bottom and gently curved sides of this bowl point to a central Banpo phase of Yangshao culture, most likely from the Weishui or lower Fenho Yangshao phase.[17] In this early period the round-bottomed, bowllike vessel appears to have been used as a lid to funerary urns in the burial of children.[18] Similar finds in Gansu have been noted; Dadiwan is the source of the earliest Banpo-phase finds in the west.[19] —J.M.W.

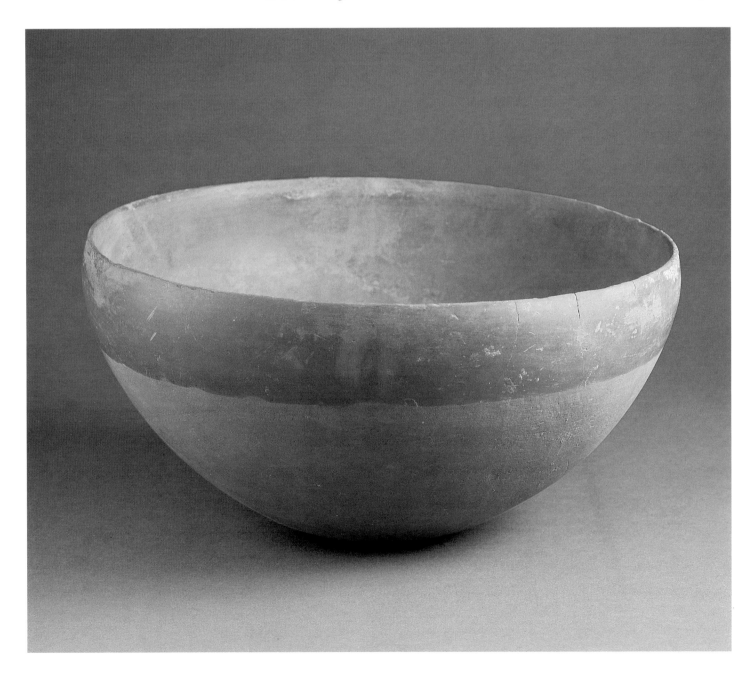

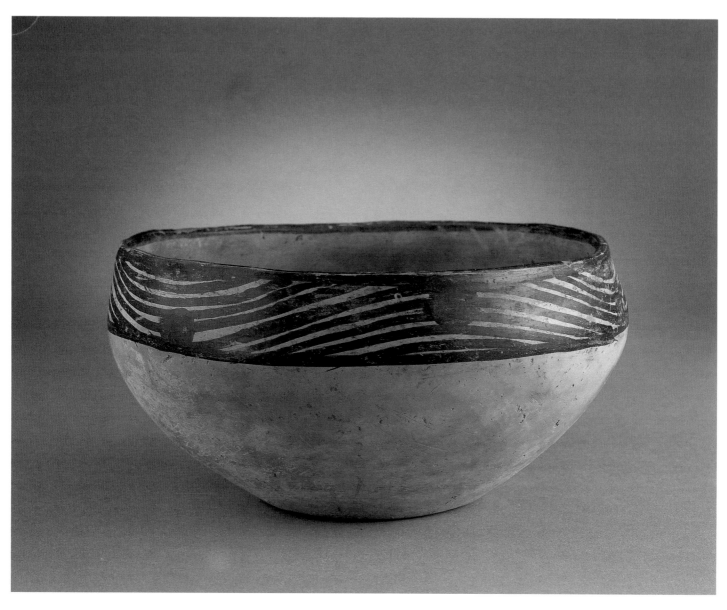

4. Bowl

Earthenware with mineral pigments
Neolithic, Gansu Yangshao culture,
Majiayao phase, possibly of the
Wangbaobao group
H: 4 3/4 in. D: 9 1/4 in.
115.1990

Wide, low, and slightly uneven, this flat-
bottomed bowl of light brown clay is
rimmed in gently undulating black min-
eral pigment, exemplifying the flowing,
linear quality of the Majiayao phase. The
bowl is decorated on the exterior lip, in
a band only a few inches wide, with a

powerful fluid line that follows the some-
what uneven lip. Its interior is undeco-
rated. There is a slight, pleasing distortion
to the shape, which lends the bowl a
supple form and imparts a natural feel
when it is held, as if it were made to fit
the hand. The base is flat, but flat ridges
indicating use of a trimming tool are ap-
parent on the inside and out, most likely
left as the bowl was finished and thinned.

Similar bowls have been discovered
in the Lanzhou, Gansu, site of Wang-
baobao.[20] The characteristic horizontal

wave bands and large black circles that punc-
tuate the flowing design clearly relate to
designs from Wangbaobao. Yan Wenming,
writing on the origin of Gansu painted
pottery, describes the Wangbaobao group
as being one of the four major groups of
Majiayao-phase ceramics.[21] The Wang-
baobao group is considered one of the last
groups of Majiayao-phase ceramics in
Gansu before the dominance of the Ban-
shan phase; it may in fact have overlapped
with the Banshan. —J.M.W.

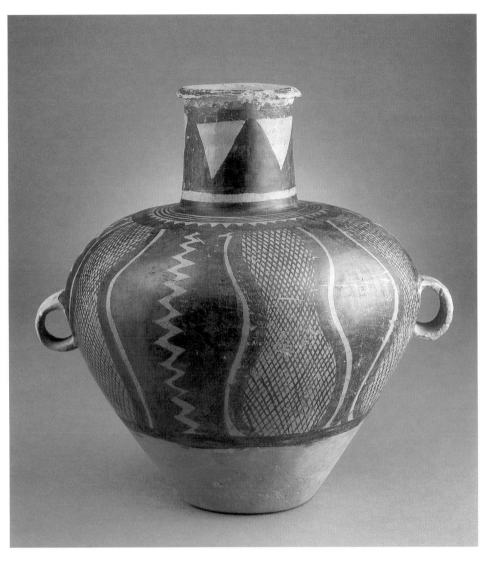

5. Storage jar

Earthenware with mineral pigments
Neolithic, Gansu Yangshao culture,
Banshan phase
H: 11 1/2 in. D: 11 3/4 in.
124.1990

Coil-built of fine, dense clay, this large storage jar is nearly as wide as it is tall. Resting on a flat, narrow base that shows evidence of trimming, the body swells near the middle portion, then constricts to a narrow, high neck with a thickly rolled lip. Two loop handles on either side of the vessel have been luted onto the middle of the body.

The painted surface decoration is unusual for its sheen as well as precision in line. The combination of red and black mineral pigment begins in the Banshan phase and is further explored in the later Machang phase. The tall neck is decorated with a black serrated pattern that emphasizes the vertical design.

The overall design, sometimes referred to as a gourd pattern, appears on a number of excavated articles from Banshan sites.[22] Periodization of the Banshan phase is difficult, with some experts regarding the quality of awkwardness in painting technique to be an indicator of an early, developmental stage of the ware,[23] while others prefer to see the sequencing from the viewpoint of overall shape combined with surface decoration.[24] The gourd pattern appears in early to late Banshan material, but the design is narrow and constricted in the earlier periods, wider in the later periods.[25] This tall-necked jar corresponds with an early to middle Banshan-period decoration and shape. Another Banshan vessel with a similar gourd decoration but a lower, rounder profile may be more firmly placed in the middle to late Banshan period (fig. 5a). —J.M.W.

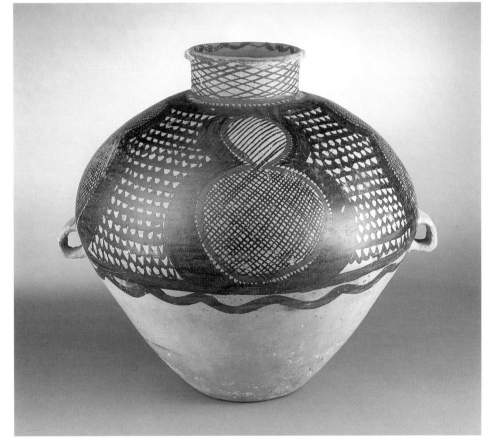

5a. Storage jar

Earthenware with mineral pigment
Neolithic, Banshan phase of Gansu
Yangshao culture
H: 14 3/4 in. D: 15 in.
214.1989

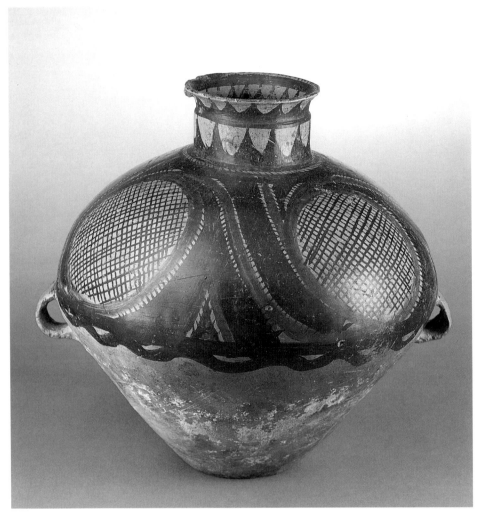

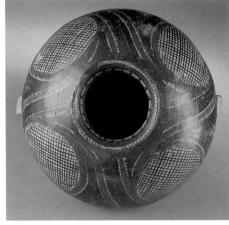

Top view, cat. no. 6.

6. Storage jar

Earthenware with mineral pigments
Neolithic, Gansu Yangshao culture,
Banshan phase
H: 12 in. D: 11½ in.
4.1987

Large two-handled storage jars with
narrow bases and wide girth are typical
of the Banshan culture. This coil-built
vessel, probably used for storage, is made
of a reddish brown clay. Its neck, wide
enough to admit a hand, has been luted to
the body; the join can be felt inside around
the neck area. The lip flares slightly at the
mouth.

Surface decoration, as with most Gansu
Yangshao storage jars, is confined to the
top two-thirds of the vessel, a practice
that may have developed out of the jar's
functional aspect; it was likely stabilized
by having its narrow base buried in sand
or soft earth.[26] The surface decoration
consists of black and red mineral pigments
painted in a graceful S-spiral fashion.

Red and black bands of color, set sharply
against the light-colored body of the ves-
sel, form an energetic and lively pattern.
A serrated pattern running between the
red and black portions of the design is
typical of Banshan ware.[27]

Across the shoulder of the jar, four
evenly placed, large circular shapes are
defined by a red band and filled with a
crisscross design. This pattern, with
many variations, is found frequently on
Banshan ware and is commonly known as
the "four large vortices."[28] This design is
thought to be a development out of the
Majiayao phase, perhaps best understood
through the pottery found at Xiaoping-
zi.[29] The pattern also survives in the
Machang-phase wares from the Gansu
and Qinghai areas.

Patterning found within the vortices
varies from jar to jar. This vessel exhibits
a straightforward netlike pattern frequent-
ly found on Majiayao objects like the Sze
Hong jar (fig. 1a) where it is seen as an

overall pattern. In fig. 6a, a highly sym-
metrical division of dots and net pattern
fills the vortices. Fig. 6b has a lively
checkerboard pattern that alternates with
an organic design of lozenge and crisscross
patterns. The vessel in fig. 6c maintains
the same strong overall S-spiral; a bold
checkerboard pattern fills all four vortices.

The four-vortices pattern continues
into the Machang phase even though the
S-spiral portion degenerates into a more
static but nevertheless highly symmetrical
pattern (fig. 6d). Here the vessel has a dif-
ferent profile; the shoulder slopes more
gradually, resulting in a lower center of
gravity. The vortices' interior patterning
continues to be symmetrical and abstract.
The serration seen so frequently in Ban-
shan ware ceases in Machang, as does the
high polish. —J.M.W.

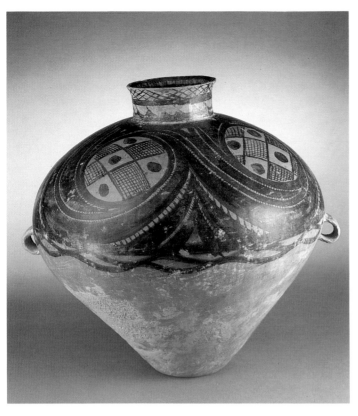

6a. **Storage jar**
Earthenware with mineral pigments
Neolithic, Banshan phase of Gansu
Yangshao culture
H: 15 3/8 in. D: 16 1/2 in.
9.1987

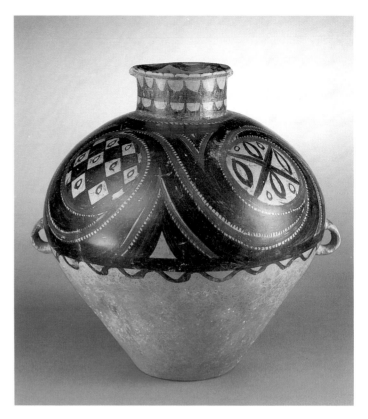

6b. **Storage jar**
Earthenware with mineral pigments
Neolithic, Banshan phase of Gansu
Yangshao culture
H: 14 in. D: 17 in.
3.1987

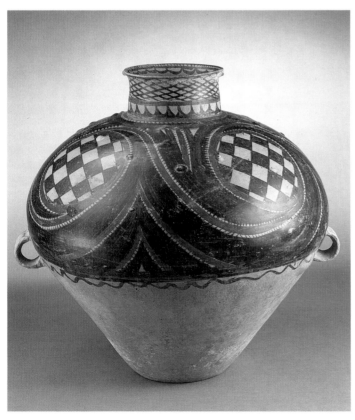

6c. **Storage jar**
Earthenware with mineral pigments
Neolithic, Banshan phase of Gansu
Yangshao culture
H: 15 1/2 in. D: 18 1/2 in.
220.1989

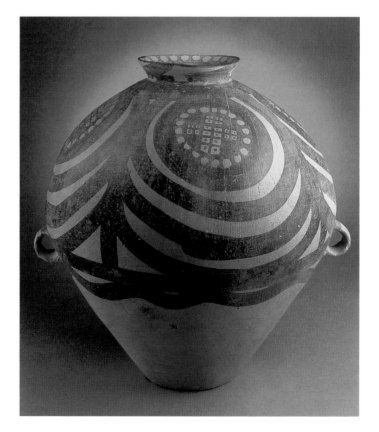

6d. **Storage jar**
Earthenware with mineral pigments
Neolithic, Machang phase of Gansu
Yangshao culture
H: 16 1/2 in. D: 15 1/2 in.
1987.3

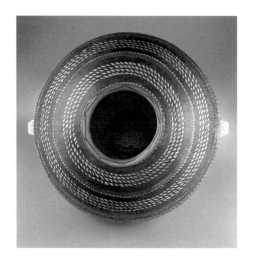

Top view, cat. no. 7.

7. Storage jar

Earthenware with mineral pigments
Neolithic, Gansu Yangshao culture,
Banshan phase
H: 17 in. D: 18 1/2 in.
167.1987

Rising from a narrow, flat base, this
tall storage jar reaches its greatest girth
slightly below its center, where two
handles have been attached at the lowest
element of the design. The neck is rela-
tively short and straight, and ends in a
slightly flaring lip and wide mouth. The
shoulder, less angular than earlier Banshan

pieces, provided the artist with a broad
and gently curving surface for the elegant
horizontal pattern that encircles the top
portion of the jar. Alternating thick, solid
red and black lines with narrow, open,
serrated lines, the design has a lively
movement and vitality. The lower portion
is finished with an intertwined, thick,
black, modulated mineral-pigment line
created with a slip. The outside of the
neck is marked by a large crisscross pat-
tern and the interior with a scalloped line
pattern.

The overall pattern, known as a rope
design, is found exclusively on Banshan-
period wares. Seen from above (see de-
tail), it is a perfectly balanced pattern.
It is commonly found on vessels that meet
the criteria of the later stage of Banshan,
that is, vessels with a sloping shoulder
and girth as wide as height.[30] A slightly
smaller storage jar (fig. 7a) shows very
much the same design; its smaller size and
slightly more everted lip are the primary
differences. —J.M.W.

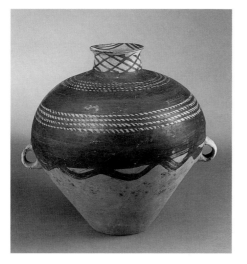

7a. **Storage jar**
Earthenware with mineral pigments
Neolithic, Banshan phase of Gansu
Yangshao culture
H: 11 1/2 in. D: 11 1/2 in.
217.1989

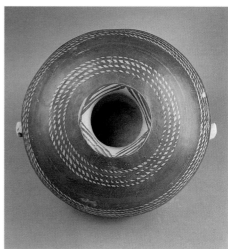

Top view, fig. 7a.

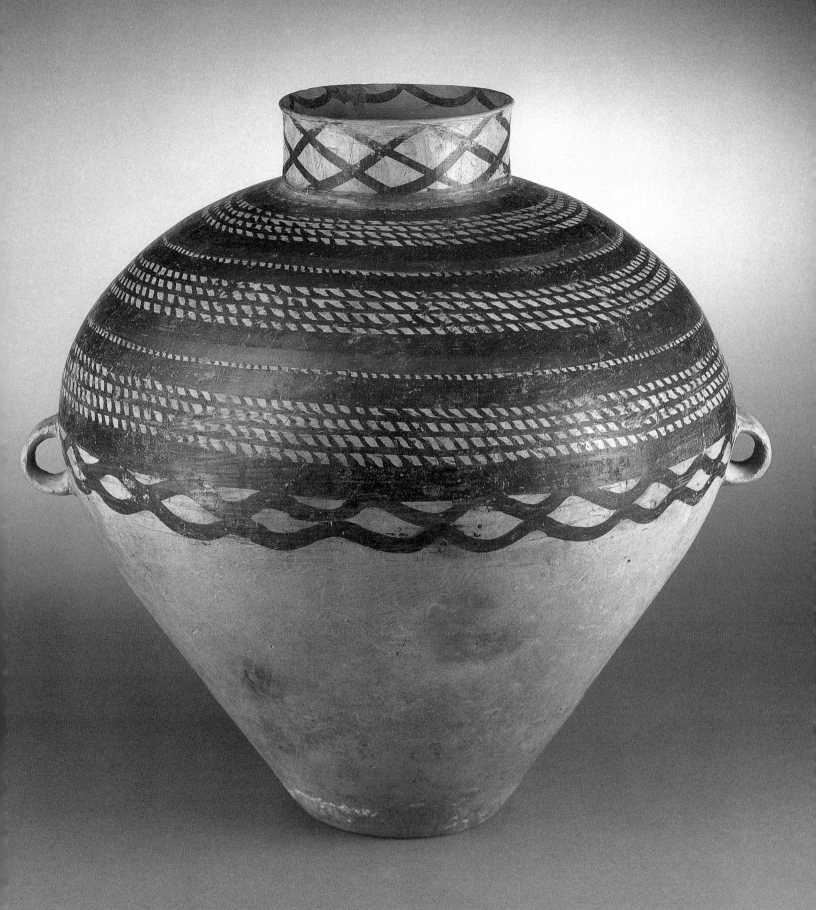

8. Storage jar

Earthenware with mineral pigments
Neolithic, Gansu Yangshao culture,
Banshan phase
H: 12 3/8 in. D: 14 3/4 in.
152.1987

Rounder and wider than many other large Banshan vessels, this storage jar resembles those of the later stages of the Banshan cultural tradition.[31] The body is light buff in color, very fine, and thinly constructed. The rounded upper shape ends in a notably truncated neck and a wide mouth with a strongly everted lip. The center of gravity in this vessel is low, as indicated by its widest girth, which occurs proportionally low on the vessel.

Surface decoration in red and black mineral pigments has been applied with a wide, sure stroke, the black line outlining the red to form an intriguing zoomorphic image that is unusual in several ways. These stick-figure designs, more commonly found among Machang cultural-phase wares than Banshan, are unique to the western Gansu-Yangshao tradition and never appear in the earlier central Yangshao tradition. Here the fineness of painting, the quality of line, the overall shape of the vessel, and its polish all point to a Banshan cultural-phase origin.[32] Typically the Machang stick-figure design lacks a head or circle at the top of the jar, is more crudely painted, and has a much more elongated profile, as seen in cat. no. 9.

The meaning of this design has provoked considerable debate. The Chinese scholar Yan Wenming identifies the figure as "an edible water frog."[33] Western scholars have preferred to call these designs "tufted zoomorphs."[34] Both opinions imply a pictorial relationship between design and meaning. Ascribing meaning to ancient designs from a modern visual viewpoint projects onto the design a life that may prove to be spurious. A pictographic interpretation relating this stick figure to a linguistic source is equally plausible.[35] Further research into the meaning of many aspects of design in Neolithic pottery is called for, including the possible link between design and early pictographic language.[36]

—J.M.W.

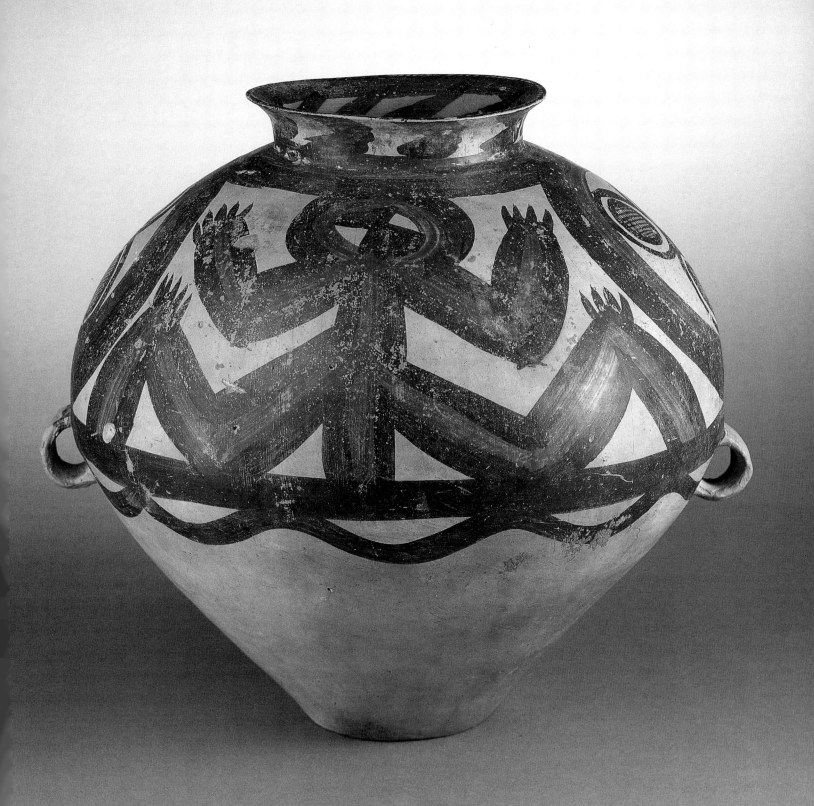

9. Storage jar

Earthenware with mineral pigments
Neolithic, Gansu Yangshao culture,
Machang phase
H: 15¼ in. D: 16 in.
154.1987

This large storage vessel with steeply
rounded shoulder, narrow base, truncated
neck, and strongly everted lip is made of
tempered, buff-colored clay. The clay
shows imperfections and some pitting
across the surface. The two handles luted
onto either side of the vessel are located
slightly below its center. Mineral-pigment
slips of red and black have been painted in
a loose and free fluctuating line.

The surface design of this vessel re-
sembles that found on cat. no. 8, a straight,
vertical line from which angular lines
project diagonally, with small tufts pro-
truding from the top and bottom of the
angles and the uppermost ends. Whether
defined as zoomorphic, geometric, or lin-
guistically connected, the design is perva-
sive throughout Machang-period wares.
The design is fully symmetrical, with
stick images on opposing sides and a large
circle with crosshatch patterning filling
the area directly above each handle. The
finish on the vessel, with its exacting
painting and rubbed surface, marks it as
one of the finer Machang wares of its
type.

The meaning of the design remains
open to speculation. K. C. Chang, in
discussing the design, which is found
in great quantity at the Qinghai site of
Liuwan, notes that this anthropomorphic
tendency is one of the "commonly en-
countered shamanic elements found in the
ethnographic present throughout the
world."[37] Because we lack proof of a
shamanistic tradition in the early forma-
tion of Chinese Neolithic society, the
designs remain an enigma. —J.M.W.

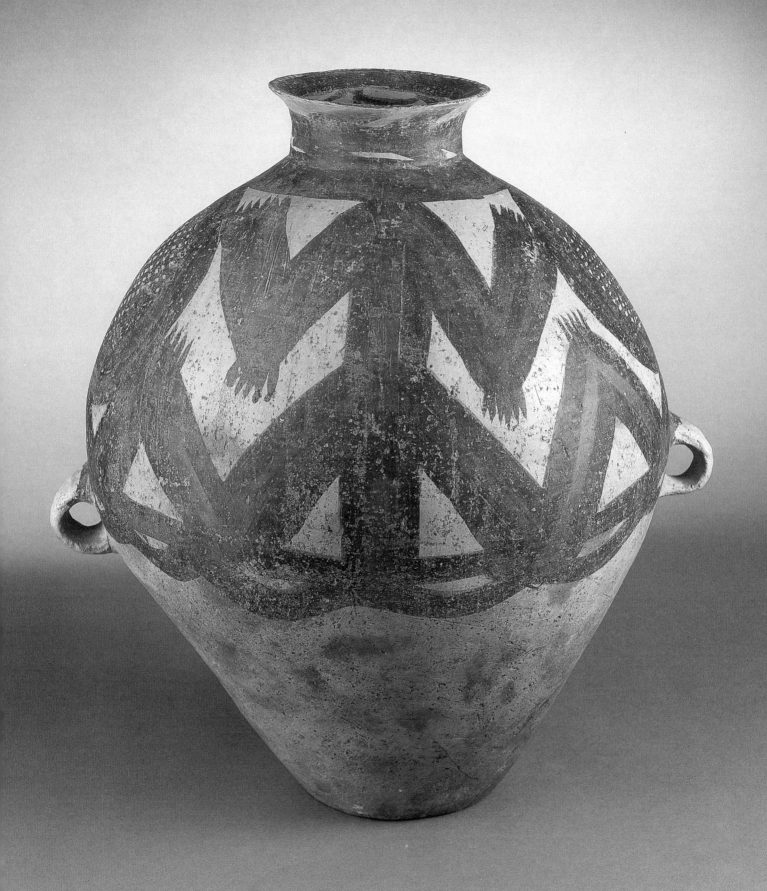

10. **Storage jar**

Earthenware with mineral pigments
Neolithic, Gansu Yangshao culture,
Machang phase, middle-period Liuwan
H: 16 ½ in. D: 18 in.
158.1987

A large storage jar with narrow base, wide girth, short neck, and flaring lip, this coil-built vessel has two opposing handles that were luted onto the body before firing. It was probably fired at a low temperature in an oxidizing atmosphere that left the clay body a brick red color. In addition to the natural reddish coloring, the upper portion of the vessel, beginning at the two attached handles, has been painted with a red wash typical of the middle Machang period and commonly seen at the Liuwan site.[38]

The painted decoration on the upper portion of this storage vessel is executed in a calligraphic black line using a black slip created from ground mineral manganese mixed with clay slip. The decoration is broken into horizontal zones, with familiar patterns arranged in a new way, a trait rarely seen before the Machang period. The decorative vocabulary draws from organic shell-like images around the widest portion of the vessel. They are topped by a horizontal band followed by a zigzag design around the shoulder. The short neck is decorated with a black banding.

A black mark resembling an X appears on the lower third of the vessel. Clearly intentional, it is a fairly common mark on ceramics, appearing at nineteen of thirty-six pre-Shang sites as well as with some frequency at Zhengzhou and in oracle-bone and bronze inscriptions.[39] A great deal of controversy exists concerning markings on pre-Shang objects. From Banpo to Anyang, a period of over three thousand years, evidence of markings exist. Many Chinese scholars see a link between the marks found on Gansu Yangshao pottery (and those found etched on Banpo pottery) and the written Chinese language.[40] Others prefer to see these marks as a system of symbols that may or may not have a direct relationship to written language but are clearly a structured system.[41] Boltz disagrees with the theory that the marks are related to Shang writings, either clan or dedicatory, citing the great time span between these marks and the Shang horizon, the inconclusive relationship between them and later pictographs, and the problems inherent in linguistic development.[42] More research is necessary before a definitive conclusion can be reached concerning these marks. It is apparent that regional variations occur in the manner in which the marks are made; some are incised, and others, like those on the Sze Hong vessel, are painted.

—J.M.W.

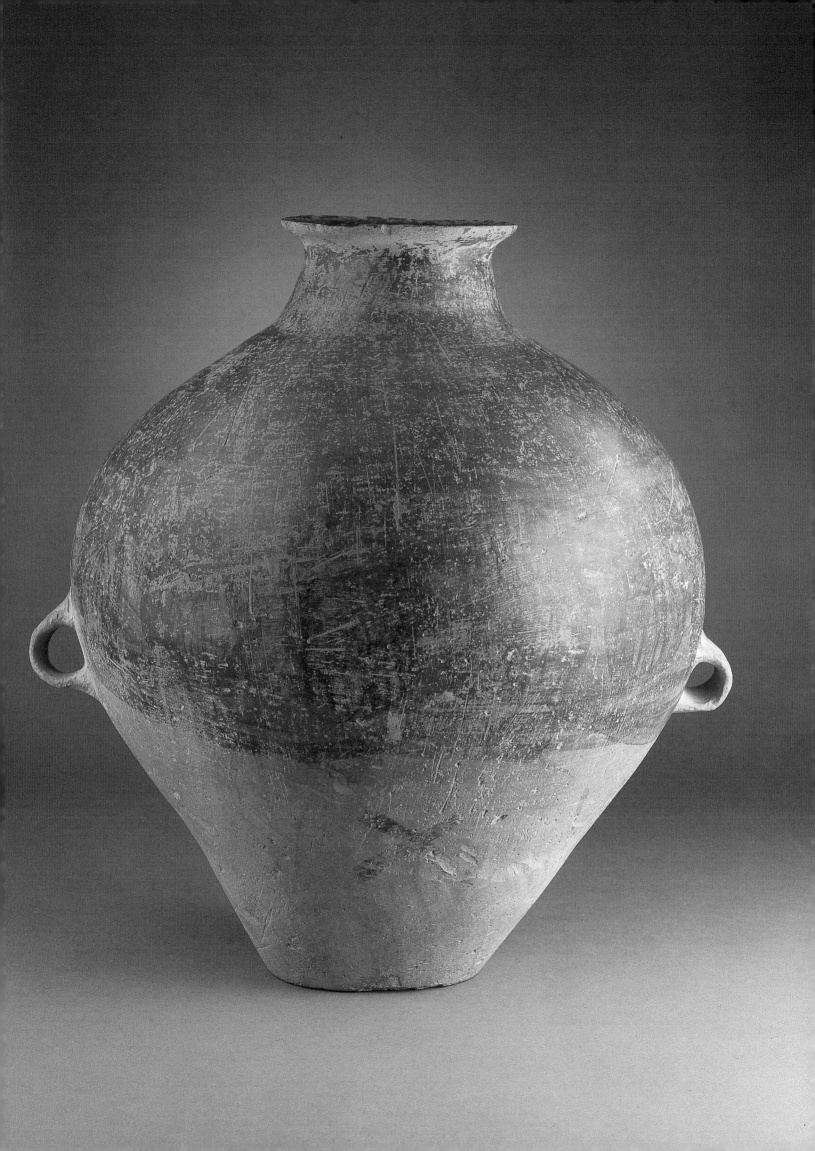

11. Storage jar with lid

Earthenware with red wash and
mineral pigment
Neolithic, Gansu Yangshao culture,
Machang phase, Liuwan type
H: 9 3/4 in. D: 9 3/4 in.
96.1990

Narrow at the flat-bottomed base, this
storage jar swells to a bulbous belly and
steeply sloping shoulder. The wide
mouth, which shows evidence of having
been cut from the top, probably in a near
leather-hard stage, is fitted with a per-
fectly matched lid. The high neck of the
lid is pierced by four opposing holes
toward the top and capped by a flat
handle. The overall shape, slightly
uneven, makes the whole vessel a little
lopsided. Ridge lines left by the potter's
coiling work are apparent on the lower,
unpainted portion of the vessel. Two
handles have been luted to opposing sides
just below the widest girth. Above the
handles, two small appendages of pinched
clay project on either side.

The upper two-thirds of the vessel is
covered in a thin, reddish brown wash
similar to that found on cat. no. 10. Below
the wash is a broad round mark resem-
bling an 0.[43] The decoration on the
vessel's shoulder consists of one large
horizontal band defined at the top by
three narrow black bands and across the
bottom by a thick black line in a swag
pattern. Across the top and around the
lip of the vessel are triangular projections
incorporating a crisscross pattern; they
extend and continue across the break from
body to lid. Above it the neck decoration
continues in black vertical lines, while the
capped portion is covered by two triangu-
lar designs, which are filled with criss-
cross patterning.

The decoration, with its red wash and
black horizontal zone painting, is consis-
tent with excavated finds from Qinghai.[44]
Similar lidded vessels have been found
in some quantity at Liuwan, Ledu xian,
Qinghai.[45] The reason for this change
in vessel type is unknown; perhaps it is
related to a modification in function or
reflected new needs within the society.
The change in both form and decorative
style is indicative of developmental shifts
that occurred within the Machang culture.

—J.M.W.

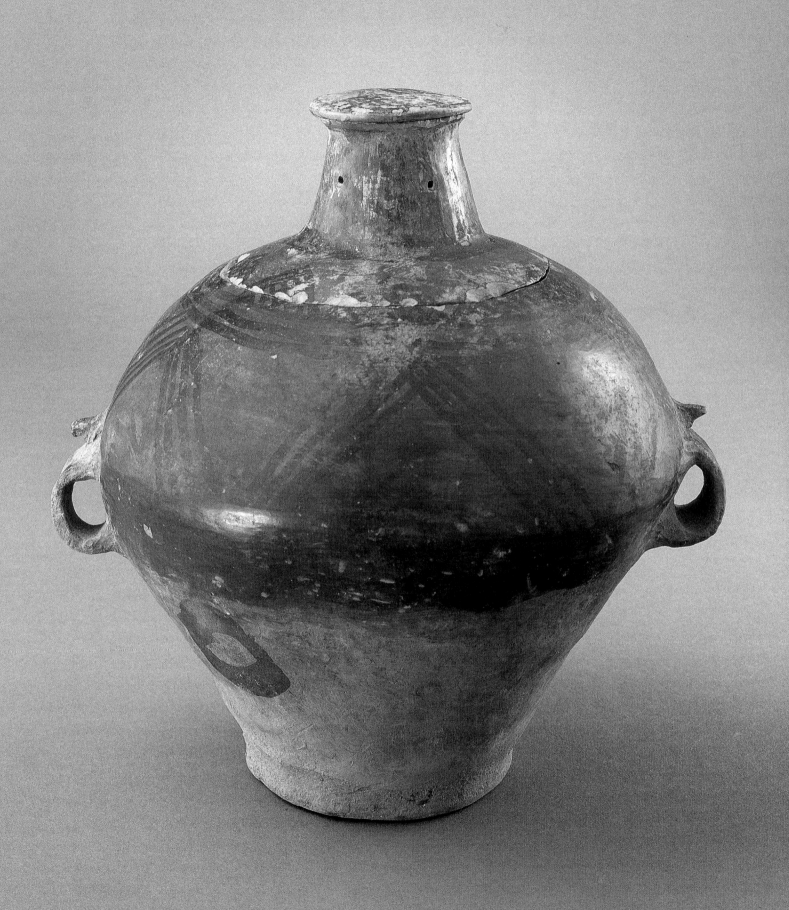

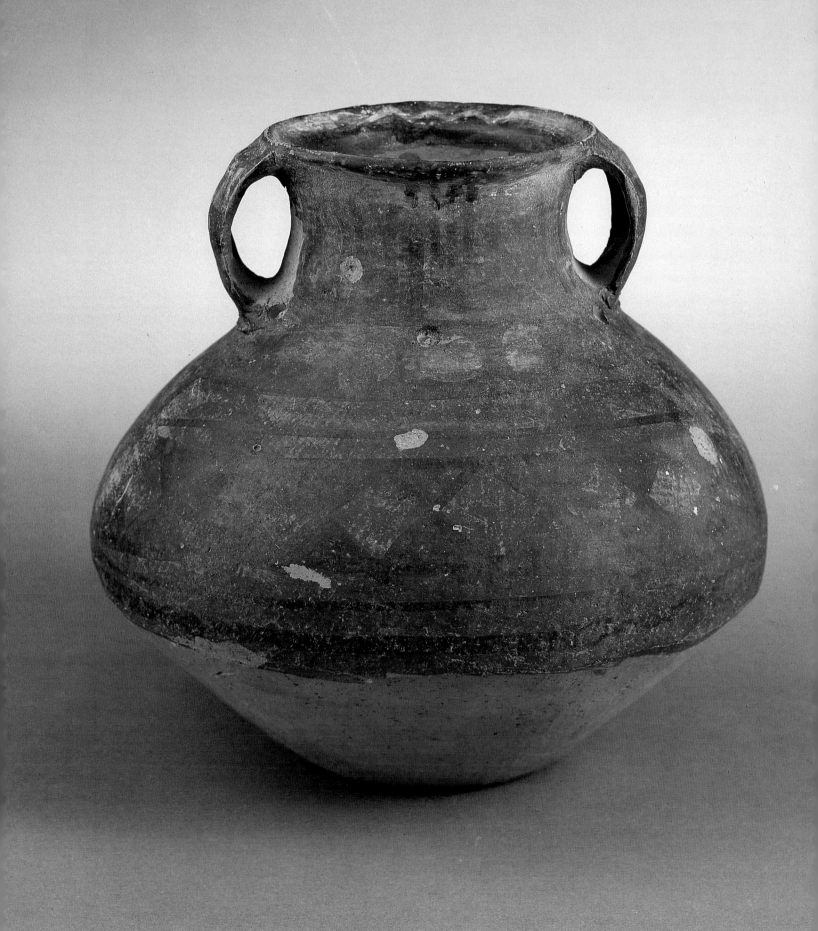

12. Storage jar

Earthenware with mineral pigments
Neolithic, Gansu Yangshao culture,
Machang phase
H: 7 1/2 in. D: 8 1/2 in.
198.1989

A low, double-handled jar of fine-grained clay, this Neolithic vessel of the Machang culture has many characteristics of the smaller vessels found throughout the Gansu Yangshao tradition. This vessel has a narrow base, a relatively low center of gravity, a girth wider than its height, and a sharply sloping shoulder that extends into a tall neck with slightly everted lip. Its lower portion is undecorated.

Circular doughnut-shaped indentations line the shoulder and top of the handles, marks clearly made while the clay was still quite wet. They are evenly spaced, three across the shoulder of each side of the vessel, with two additional marks on the middle of the top of the handle. Archaeologists at the Liuwan site in Ledu xian have described these indentations as a kind of surface decoration that was once filled with small, round, animal-bone disks.[46] This technique of inlay, which eventually preoccupied much of later Chinese bronze work, clearly had its first flowering in the pottery of the Machang craftsman.

The painted surface decoration on this vessel follows similar patterns evident on other early to middle Liuwan-style Machang-phase pottery.[47] A reddish wash covers the upper two-thirds of the vessel; a horizontally organized black line pattern is laid over the wash. Black painted bands encircle the lower portion of the design before it breaks into a linked diamond pattern that is accomplished through a reverse-painting technique. A single thin black band followed by an undecorated portion is then topped with a thicker black band that uses the same reverse technique to create a painted design of black dots within circles of red wash. The indentations lie within this band. The painted designs greatly resemble the indentations and may in fact be one of the ways that the Machang potter accomplished the same kind of design, with perhaps the same meaning or intent, without actually inlaying additional material.

This pattern is popular throughout middle-period Machang wares, as evidenced by two other Sze Hong collection wares. The larger (fig. 12a) employs the same type of surface decoration: horizontal banding, undercoat of red wash, and thick and thin black lines. The shoulder and lip decoration of circular design is apparently an attempt to indicate an inlay through painting rather than insetting. A smaller vessel (fig. 12b) with a brownish underwash employs a linear painting technique to indicate a linked pattern of circular design. —J.M.W.

12a. Storage jar
Earthenware with mineral pigments
Neolithic, Machang phase of Gansu
Yangshao culture
H: 10 in. D: 13 1/2 in.
212.1989

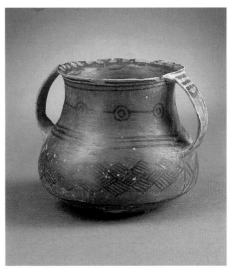

12b. Storage jar
Earthenware with mineral pigments
Neolithic, Machang phase of Gansu
Yangshao culture
H: 4 in. D: 5 in.
205.1989

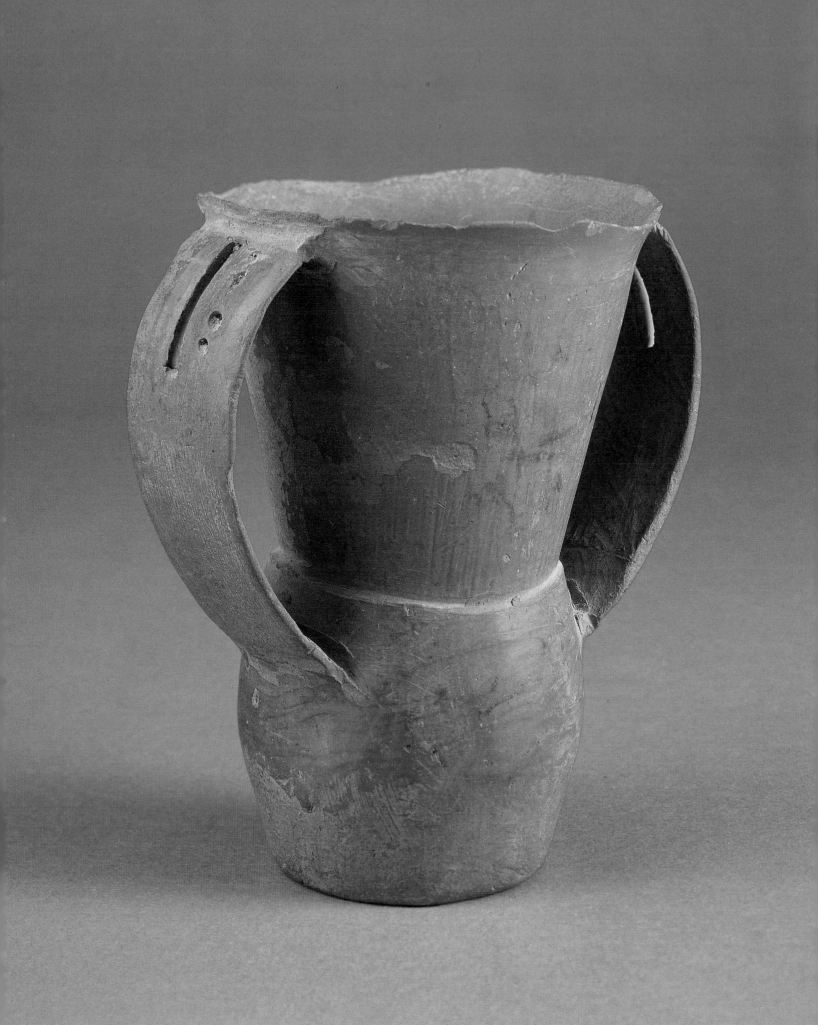

13. Cup

Earthenware
Neolithic, Qijia culture
H: 4 3/4 in. D: 4 1/2 in.
27.1987

Simple elegance is the chief attribute of this extremely thin-walled cup from the Qijia culture. Constructed of fine-grained reddish clay, the cup rises from a flat base, sharply flaring up and out from a constricted waist. The lip is irregular through wear but shows a slightly everted turn. Unpainted but delicately burnished, the surface is smooth and in areas glossy. The entire surface appears to have been thinned and trimmed with a flat instrument. Two wide, pierced handles join the cup base well below the waist and are joined to the tall neck nearly at the lip. The handles are pierced near the lip and down about one inch. Each handle is additionally marked, but not pierced through, with four round holes in vertical lines on opposing sides of the vertical slit.

Qijia-culture ceramics have been excavated from as far west as Guinan in Qinghai to the upper Weishui valley in the east.[48] Archaeological sites have been identified by Xie Duanji, who proposes a periodization of Qijia wares based on material culture from what is still a limited number of archaeologically excavated sites.[49] Through analysis and comparison of the various types of vessels, Xie concludes that Qijia wares are of a "single developmental sequence" that began chronologically in the east and moved to the west.[50] This helps to refute the once-popular theory that Chinese Neolithic wares were influenced by a dominant culture movement from the west to the east.

To place the Sze Hong cup in sequence, it can be compared to two archaeologically excavated cups from Liuwan in Qinghai province which show very similar graceful, elongated profiles.[51] From comparative stratigraphical evidence, it would appear that this long-necked type belongs to an early to middle period of Qijia ware, either Dahezhuang or Qinweijia types.[52] Several other examples of Qijia ware in the Sze Hong collection, including two cups (figs. 13a and 13b), belong to the western type associated with Huangniangniangtai.[53] According to Xie's chronology, these last two cups could be dated toward the end of the Qijia period, while this thinner, taller vessel belongs to the earlier period. —J.M.W.

13a. **Cup**
Earthenware
Neolithic, Qijia culture
H: 4 in. D: 5 1/2 in.
192.1989

13b. **Cup**
Earthenware
Neolithic, Qijia culture
H: 3 3/4 in. D: 4 1/4 in.
194.1989

14. Storage jar

Earthenware with mineral pigments
Neolithic, Xindian culture
H: 11 1/2 in. W: 11 1/2 in.
6.1987

Rising from a slightly rounded base, this storage jar of the Xindian culture is constructed of a slightly coarser-grained clay than that seen in the earlier Majiayao cultures. The proportions of the vessel are balanced. It flows from a narrow base to a wide middle section, and from a rounded, sloping shoulder to a broad, tall neck that leads to a flaring, wide lip. Two broad, flat, opposing handles were applied to the vessel just below the shoulder.

This vessel was coil-built, although not entirely by the same process as earlier coil-built pieces, as evidenced by the base. It is not entirely flat but slightly indented, showing marks that radiate from the bottom to about one-third of the way up the vessel's sides. The markings are fine and are not scratched into the surface, but appear as an integral part of the vessel. These marks possibly reflect the use of a partial support mold, perhaps a finely woven basket, which was either removed once the vessel was leather-hard or burned off in firing.[54] Paddles were used to beat and thin the clay body, and some of the markings could be the result of this process.

The surface decoration consists of a light reddish wash across the upper portion, with black painted lines organized in horizontal zones over the entire surface. The uppermost zone, from the lip to the bottom of the neck, consists of one solid black band marking the flared portion of the outer lip. It is followed by a continuous fret design that flows without interruption around the entire neck. At the base of this pattern, a jagged line runs around the contour of the vessel. The painted pattern found on the shoulder is abstracted and has been referred to as opposing deer or dog designs.[55] The lower portion is decorated to the base with a series of vertical hooked lines.

The Xindian culture follows closely on the Qijia culture and is systematically divided into four groups based on a chronology devised by Yan Wenming.[56] The primary sites for this culture are found in the upper reaches of the Huang River valley and the lower Huangshui valley.[57] The Sze Hong vessel exemplifies the typical characteristics of much of this culture's ceramic ware. Major holdings of Xindian ware can be found in the Linxia Regional Museum in southern Gansu province.

—J.M.W.

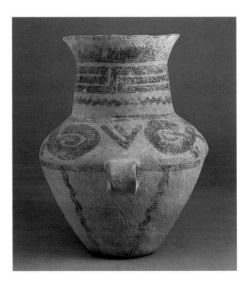

Side view, cat. no. 14.

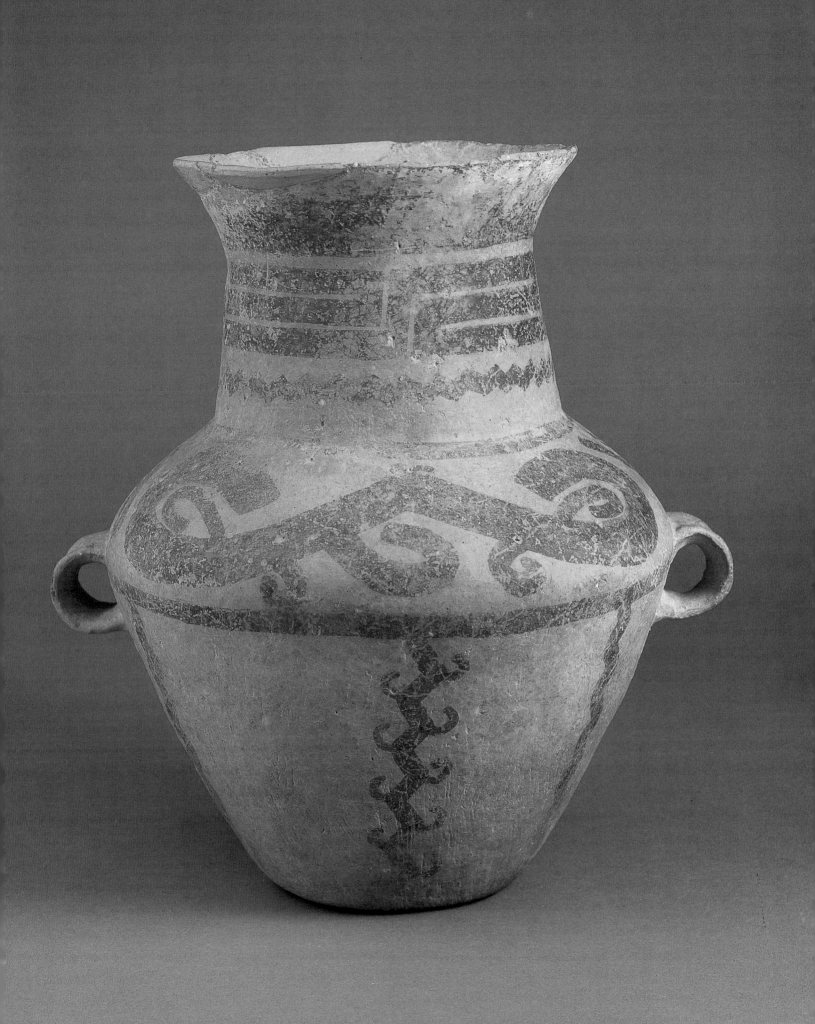

15. Bowl

Earthenware with mineral pigments
Neolithic, Xindian culture, Tang-
wang type
H: 3 1/4 in. W: 4 1/2 in. D: 3 1/2 in.
143.1990

This small round cup of the Xindian culture is constructed of a fine clay that has been tempered with sand, creating a pastelike body that can be seen on the base and inside of the vessel where it is unpainted and unburnished. The bowl has a low foot ring, probably constructed by thinning and removing clay from the base, a phenomenon rarely seen in western Yangshao pottery. The rounded body swells at midpoint and ends in a short neck with everted lip. One handle projects from the side of the vessel; it is broken and appears to have been filed and trimmed. The point where the handle would have rejoined the body has been repaired, but it is clear that the handle was originally a high loop, a typical characteristic of Tangwang-type ware.[58]

The clay body appears to be naturally red, but the exterior may have been coated with a reddish brown slip. The surface decoration of black mineral pigment is enhanced by the burnished clay body. A running spiral pattern moves rhythmically around the cup. A painted horizontal band around the shoulder, just below the neck, consists of intersected lines. The outside of the neck is simply decorated with three vertical marks; the inside of the lip is decorated with an inverted triangular pattern.

Andersson may have been the first person in the twentieth century to uncover the Tangwang-type pottery at a site in Qinghai. His assessment of the objects as belonging to Machang culture type has since been questioned.[59] Theories prevailing since those early excavations in the 1950s place the Tangwang type as a subdivision of the Xindian culture, although the group of Xindian to which it belongs has been debated.[60] Excavations carried out in the 1970s in Datong xian, Qinghai province, have brought to light a number of examples of this type of ware.[61] The Sze Hong cup, as a representative of the Tangwang type, can safely be dated to the early part of the Xindian culture.

—J.M.W.

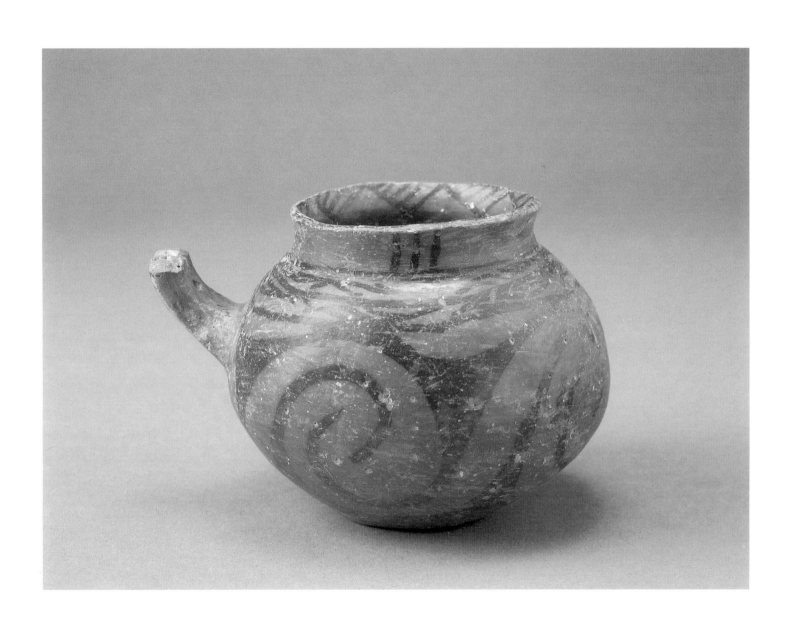

Notes

1. Construction by the hand-coil technique is a consistent characteristic of Gansu-Yangshao pottery. The term "lute" is defined by Margaret Medley in *The Chinese Potter: A Practical History of Chinese Ceramics* (London: Phaidon, 1986), p. 280: "To lute is to put two clay bodies together using slip to seal the join. Spouts and handles, as well as some decorative elements are attached to vessels in this way." See also Pamela B. Vandiver, "The Implications of Variation in Ceramic Technology: The Forming of Neolithic Storage Vessels in China and the Near East," *Archeomaterials*, 1988, no. 2, pp. 139–74.

2. All Neolithic-period vessels shown in this section are fired at a temperature of about 800 to 1020 degrees C in an oxidizing atmosphere. The iron content of the body causes the fired ceramic to remain red to buff in color. The decoration throughout is ground mineral-pigment slip, not a true glaze. See Medley, *The Chinese Potter*, pp. 17–24.

3. Chang Kwang-Chih, *The Archaeology of Ancient China*, 4th ed. (New Haven and London: Yale University Press, 1986), p. 131, fig. 89, identifies this profile as a Xiwangcun (or late Banpo) phase of Yangshao culture.

4. Gansu Provincial Museum and Gansu Provincial Cultural Relics Team, eds., *Gansu caitao* (Gansu painted pottery) (Beijing: Wenwu Press, 1984), p. 2, no. 23, shows the same kind of horizontal patterning across the neck that is found on many other shapes from bowls to bottles from the Majiayao phase. In *Qinghai caitao* (Qinghai painted pottery) (Beijing: Wenwu Press, 1980), items nos. 2 and 3 make use of a fine calligraphic line in creating wavelike bands across the shoulder of the vessel. Both of these excavated vessels are from the Majiayao phase of western Yangshao.

5. Chang, *Archaeology*, p. 141: "The geographical and chronological overlaps of these phases in eastern Kansu suggest strongly that it was in this area that the later phases, starting with Ma-chia-yao, emerged on the basis of the Shensi Yangshao Culture." See also Yan Wenming, "Gansu caitao de yuanliu" (The origin and development of Gansu painted pottery), *Wenwu*, 1978, no. 10, pp. 62–76.

6. *Gansu caitao*, p. 2, no. 23, painted amphora from Longxi xian, Chungjia ping, excavated 1971.

7. See Denise Patry Leidy, "Tufted Zoomorphs: Figural Images in Machang Ceramics," *Journal of the Museum of Fine Arts, Boston* 1 (1989), pp. 23–30, for a discussion of the "zoomorphic tufts" design in the Machang phase of Yangshao culture. Thanks are due to Nicholas Grindley, who brought this article to my attention.

8. See Wang Zhijun et al., *Banpo yizhi* (Banpo site) (Xian: Shaanxi Renmin Meishu Press, 1987), n.p. Examples of painted pictographic forms of birds and animals have been found on a number of Banpo wares.

9. 457.1987 and 458.1987. 458.1987 is considerably wider in the vessel body and most likely belongs to the Banpo cultural phase.

10. See Chang, *Archaeology*, p. 129, fig. 87. The Sze Hong vessel 457.1987 is similar in shape to a vessel said to be from Qiangzhai and of the Shijia phase.

11. Wang, *Banpo yizhi*, n.p., with illustrations.

12. A similar low-waisted shape was found in Datong xian, Shengsunjia zhai, in 1976 (illustrated in *Qinghai caitao*, p. 2, no. 9). This vessel has been described as being from the Majiayao phase. In quality of painting the Sze Hong piece is far more precisely executed.

13. See a bowl slightly less dramatic in shape but with a similar painted design in *Gansu caitao*, p. 3, no. 35, said to be from the Majiayao phase.

14. Ibid., p. 4, no. 46, for a vessel excavated in 1975 at Yongdeng xian, Kejia ping, and said to be Majiayao. The central-band patterning, with its black triangular shapes emanating from a central roundel that has been marked into quarters, is very similar to the band directly above the waist of the Sze Hong vessel.

15. Xian Banpo Museum et al., *Xian Banpo* (Beijing: Wenwu Press, 1985), n.p.; see photo ills. 62 and 65.

16. Thanks to extensive scientific excavations carried out at Banpo village and other central Yangshao culture sites, we have a remarkably clear picture of how the community lived and worked. For a detailed discussion in English, see Chang, *Archaeology*, chap. 3, pp. 107–91. See also Li Hui-lin, "The Domestication of Plants in China: Ecogeographical Considerations," in *The Origins of Chinese Civilization*, ed. David Keightley (Berkeley and Los Angeles: University of California Press, 1983). Li, p. 31, describes the origin of the use of hemp in early Chinese culture.

17. See profiles of Banpo Yangshao culture pottery in Chang, *Archaeology*, p. 129. See also Wu Shan, *Zhongguo xinshiqi shidai taoqi zhuangshi yishu* (The decorative art of Chinese Neolithic pottery) (Beijing: Wenwu Press, 1982), p. 83, ill. no. 13, item 1, excavated at Banpo, 1954–57.

18. Wang, *Banpo yizhi*, n.p.; see photographs taken of Banpo village and the accompanying description of the burial of children at this site.

19. See *Gansu caitao*, no. 2, which was found in Chinan xian, Dadiwan, in 1978 and is said to be of the Banpo phase of the Gansu Yangshao culture. The Dadiwan site provides us with one of the earliest horizon dates for Banpo-phase ceramics in Gansu, approximately 5100 B.C. For a complete report see Yan, "Gansu caitao de yuanliu," pp. 62–76. Note the mark etched into the surface of the outer rim of this vessel. Both central and western Yangshao bowls of this type frequently show such markings, which are thought by some scholars to be closely related to the development of early written language.

20. Cultural Work Team of the Gansu Provincial Museum, "Lanzhou Majiayao he Machang leixing muzang qingli jianbao" (Excavations of the Neolithic tombs of the category of Majiayao and Machang culture in Lanzhou), *Wenwu*, 1975, no. 6, p. 77, ill. no. 2.

21. See Yan, "Gansu caitao de yuanliu," p. 66.

22. See *Gansu caitao*, p. 6, no. 70, excavated at Huazhaizi, near Lanzhou.

23. See Nils Palmgren, "Kansu Mortuary Urns of the Pan Shan and Ma Chang Groups," *Palaeontologia Sinica*, ser. D, vol. 3, facs. 1 (Beijing: Geological Survey of China, 1934).

24. See Zhang Pengchuan, "Caitao yishu zongheng tan" (A discussion of painted pottery design), *Meishu*, 1983, no. 8, pp. 9–16. See also Cheng Wei, *Zhongguo caitao yishu* (The art of Chinese painted pottery) (Shanghai: Shanghai Renmin Press, 1985), pp. 28–32. Neither refers to specific C-14 or stratigraphic evidence.

25. For a more scientific approach to a periodization of the Banshan phase, see Cultural Work Team of Gansu Provincial Museum, "Gansu Lanzhou Jiaojiazhuang he Shilidian de Banshan taoqi" (Banshan pottery from Jiaojiazhuang and Shilidian, Lanzhou, Gansu), *Kaogu*, 1980, no. 1, pp. 7–10. From evidence of the Huazhaizi site near Lanzhou, it appears that the tall neck and thick, rolled lip apply to the early period of Banshan. The narrow, vertically attenuated gourd pattern is also said to belong to the early period.

26. From habitation-site finds it is clear that the vessels rested on the ground in a prehistoric dwelling. It seems likely that the lower portion was left undecorated either because it couldn't be seen or because the vessel was pushed into the soft earth to stand upright, and thus any lower decoration might have been spoiled by abrasion.

27. J. Gunnar Andersson, in "Researches into the Prehistory of the Chinese," *Bulletin of the Museum of Far Eastern Antiquities* 15 (1943), p. 139, refers to this as a "death pattern," largely because his experience in the Gansu area was limited to mortuary finds, which he then took to be the only source for this type of decorated pottery. In fact, excavations from 1963 at Qinggangcha have shown that similar pottery may also be found in habitation sites. See Gansu Provincial Museum, "Gansu Lanzhou Qinggangcha yizhi shijue jianbao" (Excavation report on the Qinggangcha site in Lanzhou, Gansu), *Kaogu*, 1972, no. 3, pp. 26–31.

28. See Yan, "Gansu caitao de yuanliu," p. 69.

29. Ibid.

30. See *Gansu caitao*, p. 7, no. 90, for a large vessel excavated in 1975 from Lexiang xian, Fanjiayuan. Another from Tugutai is illustrated in Chang, *Archaeology*, p. 147.

31. *Gansu caitao*, p. 7, no. 90. Stratigraphical evidence of Banshan shapes is sketchy, but at least among the larger storage vessels, contours follow the pattern outlined above—moving from a tall-necked, narrow-based vessel with wide shoulder to a rounder and more evenly proportioned shape.

32. Ibid., p. 8, pls. 114 and 115. Both are from Lanzhou and of the Banshan period.

33. Yan, "Gansu caitao de yuanliu," p. 72.

34. Clarence Shangraw uses the term "zoomorph" in *Origins of Chinese Ceramics* (New York: China Institute in America, 1978), p. 68. More recently Denise Patry Leidy discusses the relationship between these designs and later patterns found on Shang bronzes and explores the possibility of their relationship to shamanistic practices in "Tufted Zoomorphs," pp. 23–30.

35. The description of this image as that of an animal or man seems inappropriate. The image bears little resemblance to a naturalistic or realistic depiction of the human figure as seen in other Neolithic renderings of humans. Research cur-

rently underway by this author indicates that some of the designs employed by the Neolithic potter have more basis in communicating the contents of the vessel than in imaginative or symbolic imagery.

36. Cheng Zheng, associate research fellow of the Shaanxi Traditional Chinese Painting Institute, has been involved in investigating designs found on Neolithic pottery with the intent of deciphering meanings in design, especially Xindian-period wares. To the best of my knowledge, he has not yet published his findings.

37. Chang, *Archaeology*, p. 150.

38. Archaeological Team (CPAM) of Qinghai Province and Institute of Archaeology (CASS), *Qinghai Liuwan*, vol. 2 (Beijing: Wenwu Press, 1984), pp. 110–16.

39. Cheung Kwong-yue, "Recent Archaeological Evidence Relating to the Origin of Chinese Characters," in Keightley, *The Origins of Chinese Civilization*, pp. 372–73. Cheung presents a comprehensive study of early Chinese "markings" on Neolithic pottery, citing both Chinese- and English-language sources.

40. Yu Xingwu, "Guanyu gu wenzi yanjiu di ruogan wenti" (A number of questions regarding ancient character research), *Wenwu*, 1973, no. 2, pp. 32–35. Yu identifies a numbering system and attempts to "interpret" other marks, offering meaning based on relationship to Shang bronze graphs.

41. Cheung, "Recent Archaeological Evidence," in Keightley, *The Origins of Chinese Civilization*, pp. 323–91.

42. William G. Boltz, "Early Chinese Writing," *World Archaeology* 17, no. 3 (1986), pp. 420–36.

43. See Cheung, "Recent Archaeological Evidence," in Keightley, *The Origins of Chinese Civilization*, pp. 372–73. Cheung's analysis of the markings of this type shows a much more limited range, with most coming from western Gansu Yangshao sites. See cat. no. 10 (above) for additional references to the meanings of marks on Neolithic pottery.

44. See *Qinghai caitao*, p. 13, no. 74, from Mingho xian, Shan cheng, excavated in 1974.

45. See *Qinghai Liuwan*, vol. 2, pp. 141–43. A number of examples that may originally have had lids are illustrated. All are from the Machang phase; most have an undercoating of red wash.

46. From conversations I had in 1988 at Liuwan with Mr. Chen Guoxian and Mr. Li Szwu, it was clear that the burial finds at Liuwan included many small bone disks that fit the indentations. Machang tombs have yielded small stone, clay, shell, and bone disks, as recorded in *Qinghai Liuwan*, vol. 2, pp. 63–66. Mr. Chang Yongxin, assistant director of the Qinghai Provincial Museum, kindly introduced me to the staff at the Liuwan site.

47. See *Qinghai Liuwan*, vols. 1 and 2. Additional Machang finds from sites throughout Gansu are recorded and summarized by Yan, "Gansu caitao de yuanliu," pp. 62–76.

48. Chang, *Archaeology*, pp. 280–81.

49. See Xie Duanji, "Shilun Qijia wenhua yu Longshan wenhua de guanxi" (A discussion of the relationship between Qijia culture and Longshan culture), *Wenwu*, 1979, no. 10, pp. 60–68.

50. Ibid., p. 67; translation in Albert E. Dien et al., *Chinese Archaeological Abstracts, 2*, vol. 9 of *Monumenta Archaeologica* (Los Angeles: University of California, 1985), p. 294.

51. See *Qinghai caitao*, pp. 25–26, pls. 159 and 160. Both cups are painted with a delicate red pigment. The decorations show a great deal of Majiayao cultural influence.

52. See Xie Duanji, "Lun Dahezhuang yu Qinweijia Qijia wenhua de fenchi" (A discussion of the stages of development of Qijia culture at Dahezhuang and Qinweijia), *Kaogu*, 1980, no. 3, pp. 248–54. See illustration, p. 250, no. 3, tomb 54, lower left corner.

53. See Xie, "Shilun Qijia wenhua yu Longshan wenhua de guanxi," p. 66.

54. Evidence of basketry appears in Neolithic cultures as early as the Banpo phase of the Majiayao culture. See cat. no. 3 (above) for a discussion of the use of matting for preparing a vessel. Evidence of textile remains on Qijia wares from Tahochuang in Gansu are cited in Gansu Archaeological Team of IAAS, "Gansu Yongqing Tahochuang yizhi fajue baogao" (Excavation of the remains of Qijia culture at Tahochuang in Yongqing county, Gansu), *Kaogu Xuebao*, 1974, no. 2, pp. 29–62. See especially the illustration of a double-handled vessel from site M34:6.

55. Cheng Zheng, associate research fellow of the Shaanxi Traditional Chinese Painting Institute, describes this design as two stylized dogs, a theory which he communicated to me verbally in the fall of 1988. To the best of my knowledge he has not yet published his findings.

56. Yan, "Gansu caitao de yuanliu," p. 73, divides the Xindian culture into Tangwang, Zhangjiaju, Sishiding, and Xindian.

57. See Chang, *Archaeology*, pp. 376–84.

58. Ibid., p. 381: "The most conspicuous feature is the very large loop handle, often higher than the mouth." Fig. 318, p. 382, shows in the lower right-hand corner a handled cup that may approximate the appearance of the original Sze Hong handle.

59. See Andersson, "Researches," pp. 160–61 and pls. 107 109.

60. An Zhimin, "Gansu yuangu wenhua jiqi you guan de jige wenti" (Several questions regarding Gansu's ancient culture), *Kaogu Tongxun*, 1956, no. 6, pp. 9–19, initially divided the Xindian group into A and B, at the same time asserting that the Tangwang type belonged to group A. Yan, "Gansu caitao de yuanliu," p. 73, notes a greater similarity to group B material. He also proposes a four-part chronology for the Xindian material; see cat. no. 14 (above).

61. *Qinghai caitao*, pls. 170–72.

Shang and Zhou Dynasties

16. *Jue*

Bronze, not inscribed
Early Shang dynasty, 16th–15th
century B.C.
H: 6 5/8 in. W (at mouth): 6 5/8 in.
by 2 5/8 in.
617.1987

With its flat bottom, small rim-mounted posts, and thin legs, this early version of the *jue* tripod vessel has features associated with examples of bronze *jue* from sites at Zhengzhou.[1] The decoration around its waist is a thin thread relief in an angular meander pattern, similar to a painted design that appears on Neolithic pottery (see cat. no. 14) and to the fine, squared *leiwen* (spirals) of later bronzes (see cat. no. 17). The simple design was carved directly into the interior surface of a sectioned mold, which when cast produced a form with raised linear decoration.[2] The flat base of this *jue* is elliptical with pointed ends, and its legs are aligned with the seam marks where its mold sections were joined.

Used for wine, the *jue* is the earliest surviving form of Chinese bronze burial vessel. It is asymmetrical, with an elongated lip rounded at the spout and pointed at the rear. Standing on three legs, it has two small posts on its rim at the springing of the spout, and a vertical handle on one side. Unlike other early Chinese bronze forms, the *jue* seems to have no pottery prototype from the Neolithic period. Although there are a number of ceramic *jue* from Erlitou, a pre-Shang or early Shang site near Luoyang, these are thought to imitate metalwork rather than precede its manufacture.[3]

The thickened lip on this bronze is a characteristic of early bronze *jue*. It may derive from the folded lip of a hammered metal vessel, but opinions differ on the early development of smithing in China. Pottery copies of metalwork are cited as indirect evidence for hammering and annealing techniques; archaeological records, however, have yet to reveal this connection directly. An alternate explanation for the thickened lip on pottery vessels is that it represents the join-line formed between the mold and core in the metal prototype.[4]

—R.Y.O.

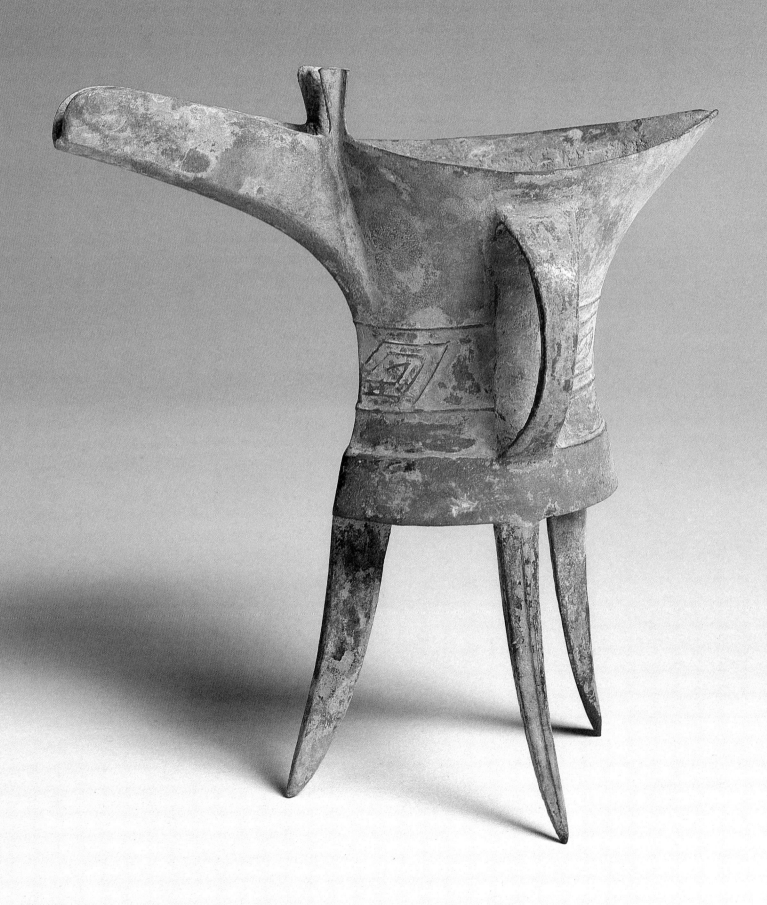

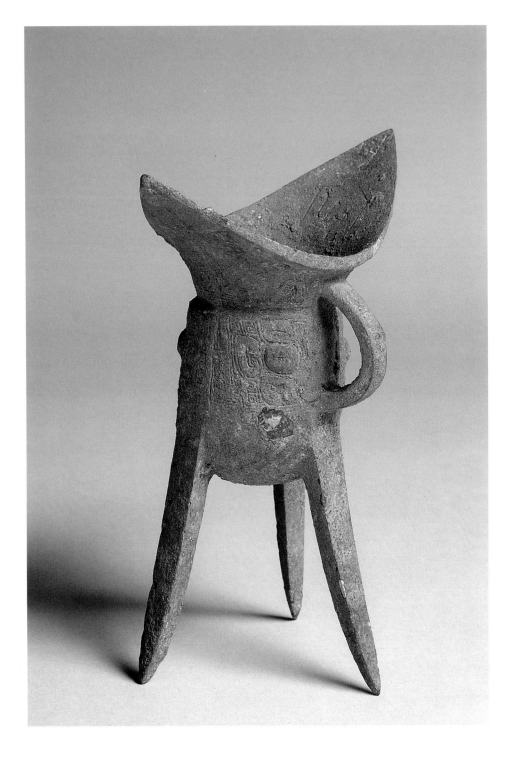

17. *Jiao*

Bronze, inscribed
Shang or early Western Zhou dynasty,
11th century B.C.
H: 6½ in. W (at mouth): 5⅛ in. by
2¹¹/₁₆ in.
328.1987

In shape, decoration, and use, *jiao* and *jue*
wine vessels are closely associated. *Jiao*
have a symmetrical lip with two pointed
ends, unlike the asymmetrical *jue* with its
rounded spout. This *jiao* stands on three
bladelike legs that are triangular in sec-
tion. Its bowed handle, aligned over its
centered leg, interrupts a decorative band
surrounding its body. Bisected by this
handle, a dismembered *taotie* face appears
amid squared spirals of the *leiwen* motif.
The *taotie* mask on the vessel's side oppo-
site the handle has a vertical ridge at its
center. The curved lip of this *jiao* follows
a catenary arc, and its rim tapers to a
sharp edge. A row of upward-pointing
triangular elements rises from the egg-
shaped body onto the lip.

An abraded three-character inscription
appears on the inner surface of the lip. Al-
though difficult to see, the inscription is a
dedication to a woman. It begins with the
same two characters inscribed on seven
vessels from a partial set of bronzes that
includes two *jiao* of similar size and appear-
ance to this example.[5] Thus, it is likely
that this *jiao* is from a set of ritual vessels.
A cache of bronzes with a shared clan in-
scription reportedly from Shandong Fei-
cheng and dating to the late Shang or early
Zhou dynasty includes two *jiao*.[6] Later in
the Western Zhou period, standard wine
vessels like the *jiao* and *jue*, which had pre-
vailed since the Shang, all but disappear.[7]

—R.Y.O.

18. *Gu*

Bronze, inscribed
Shang dynasty, 12th–11th century B.C.
H: 11 5/8 in. D (at mouth): 6 3/8 in.
478.1987

Taotie masks appear on the waist and flaring foot of this tall *gu*; they emanate between the flanges that divide the trumpet-shaped wine vessel into quadrants. The dismembered *taotie* masks are separated by areas of tight, squared *leiwen* spirals. This pattern also appears on the relief representation of the *taotie* faces, so that their raised surfaces blend with the textured background. The spiral decoration is worn nearly smooth on the raised motifs of the waist, collar, and lower neck, presumably where the vessel was handled.

Collars above and below the waist of the *gu* are embellished respectively with bands of confronted snakes and profile dragons. Two cross-shaped indentations appear between the *gu*'s waist and flaring foot; they are set below the floor of the vessel's interior, where a flat septum of cast bronze divides its upper chamber from the hollow foot. An inscription inside the foot consists of a cruciform *ya xing* surrounding what appears to be the character *you*. This mark is also found in a dedication to Fu Ding on a *li ding* in the Arthur M. Sackler Gallery, Smithsonian Institution.[8]

Wine vessels of the *gu* type enter the Shang repertoire of bronze shapes later than *jue* or *jiao* tripod vessels. *Gu* represent an ancient form, however, since ceramic examples of this vessel are known from Erlitou. While bronze *gu* from the Erligang period are rare, they become as common as *jue* by the Anyang.[9] Distinguished by a curved profile, *gu* follow a general development from vessels with wide, stout proportions to those with tall, slender forms. This *gu* has a straight midsection, a high waist, and no bulge around its center. Comparable *gu* with elongated proportions are known from Anyang, as well as in several museum and private collections.[10] —R.Y.O.

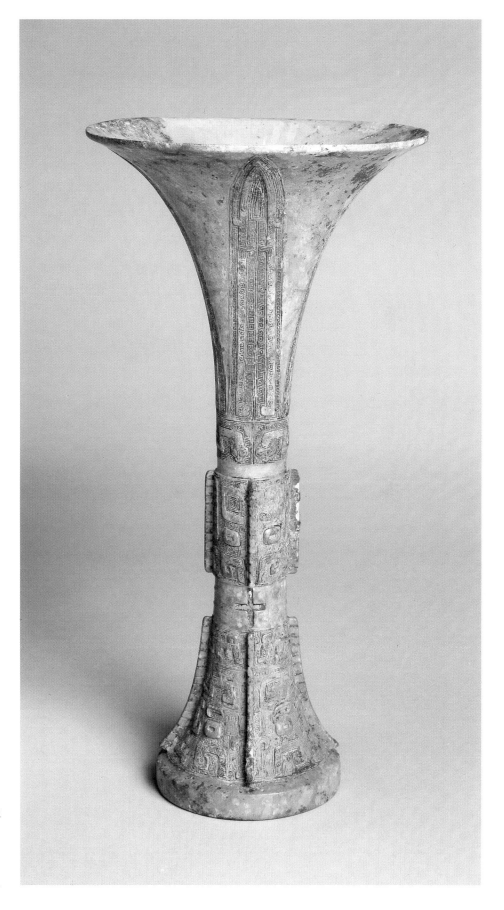

19. *Zun*

Bronze, inscribed
Shang dynasty, 11th century B.C.
H: 10 ½ in. D (at mouth): 8 ¼ in.
480.1987

Zun are jar-shaped wine vessels that occur in different shapes, including those with either round or square sections. One form has a flaring lip, shouldered body, and high foot ring. This shouldered type was later replaced by a cylindrical *zun*, similar to a *gu* in appearance but with a wider body and mouth. This *zun*, an example of the latter type, has a tall, columnar form with large *taotie* faces on its body and foot. These *taotie* have linear details within their raised features, but there are no *leiwen* spirals either on the raised images or in the background.

The body and foot of this *zun* are divided into sections by four vertical flanges. Thread-relief lines encircle it above and below the body, and its upper portion is unadorned except for two lines around its lower neck. In general appearance, this bronze is similar to a *zun* in the Arthur M. Sackler Gallery, Smithsonian Institution, that is inscribed with a dedication to Fu Gui. The form of the character *gui* in this inscription is characteristic of its appearance on bronzes that date no earlier than the next-to-last Anyang reign.[11]

The inside wall of this *zun* has a slight ridge where the neck and body join; its interior is otherwise smooth. Centered at the bottom of its rounded interior is an intaglio inscription set between three metal chaplets, or casting spacers.[12] The inscription on this vessel dedicates it to Fu Ji. A second *zun* from the Arthur M. Sackler Gallery bears an inscription with a similar but longer dedication.[13] —R.Y.O.

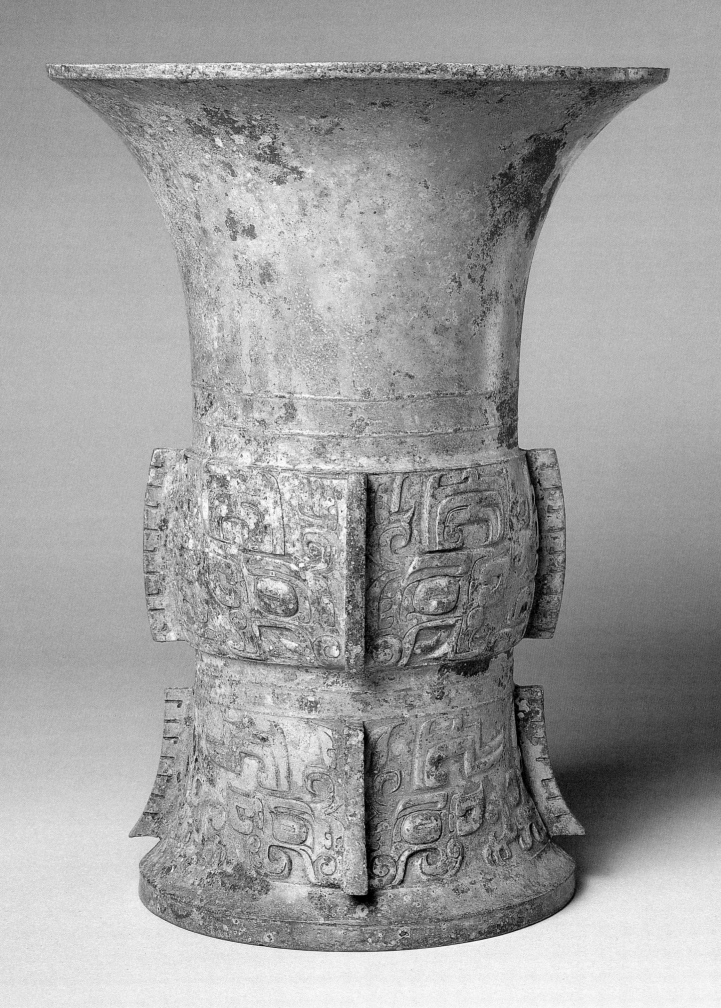

20. *Hu*

Bronze, not inscribed
Shang dynasty, 13th–12th century B.C.
H: 10¼ in. w (at mouth): 4¹³⁄₁₆ in.
by 4¼ in.
559.1987

Like the previous vessel types, *hu* are con-
tainers for wine. Ceramic examples of *hu*
with horizontal bands of decoration are
known from Zhengzhou.[14] Also from
Zhengzhou is a bronze *hu* with a lid and
attached handle. It is circular in section
and may represent an ancestor of the *hu*
form with oval cross sections like this
one. Present evidence indicates that the
flattening of vessel bodies from circular to
elliptical forms occurred not much earlier
than the Anyang period. It may have re-
sulted from a desire to have a broader
surface for decoration.[15]

The contour of this *hu* is distinguished
by its S-shaped profile. Its lower body
has a pronounced curve that rises into
a slightly flared mouth. In the register
around its neck is a decorated band of
fairly even texture. *Taotie* with bladelike
quills are depicted with very little contrast
to the background. The *taotie* are flanked
by a pair of vertical lugs delineated with
bovine faces. They provide open channels
for the possible attachment of a handle.
Other vessels of this type, however, have
core material remaining in their lugs,
indicating that handles were not neces-
sarily affixed.[16]

Wide, raised bands encircle the mouth
and foot. The area between the *hu*'s undeco-
rated mouth and the *taotie* register is ringed
by two thread-relief lines. The foot is sur-
rounded by a row of barbed spirals and
has small holes just beneath the body,
aligned under the lateral lugs. Most of the
body is undecorated, but certain areas
bear a mineralized woven texture, indicat-
ing that the vessel was buried in contact
with a textile.[17] —R.Y.O.

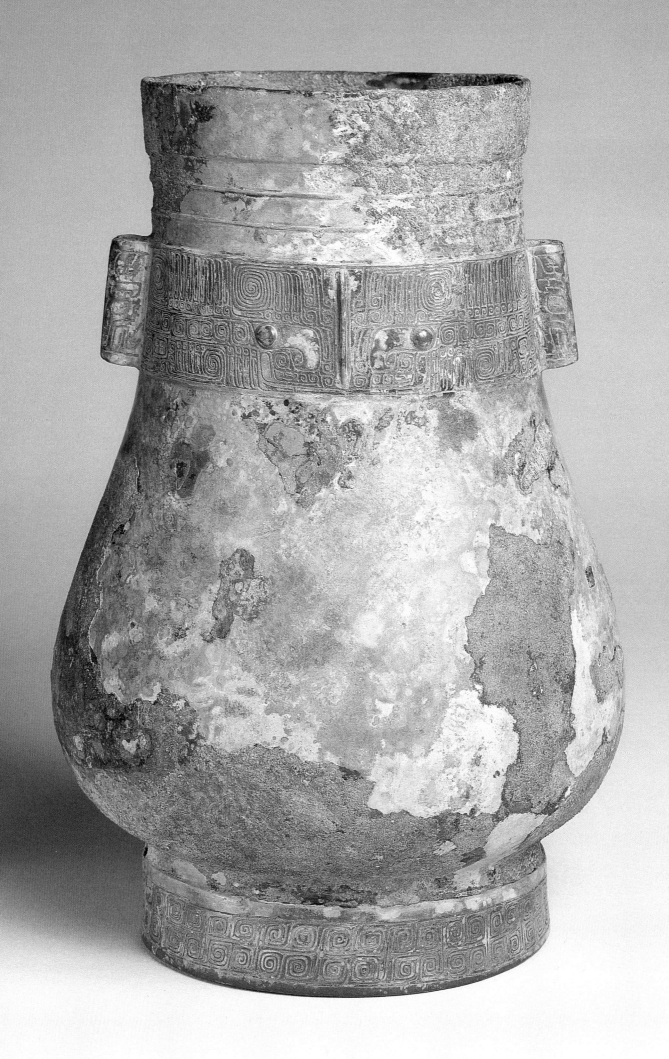

21. *You* with handle

Bronze, inscribed
Western Zhou dynasty, 11th–10th
century B.C.
H (with lid): 9 3/8 in. H (to rim): 6 1/4 in.
W (at mouth): 5 1/8 in. by 3 13/16 in.
474.1987

In shape and decoration, many parallels
exist between *you* and *hu*, making it
sometimes difficult to distinguish them.[18]
You are ritual wine vessels with domed
lids and U-shaped handles; their ancestry
extends back to the Shang, when several
you varieties were developed including
those with round, oval, square, and
double-owl shaped bodies. By the begin-
ning of the Zhou, oval-bodied *you* with
handles set across the long axis become
well established. In general, the surface
treatment of *you* evolved in two directions
—decorated and plain. *You* covered with
decoration are more numerous than those
with starkly plain exteriors and may re-
flect a difference in cost, the elaborate ves-
sels being more expensive than their
simpler counterparts.[19]

In cross section, the body of this plain-
bodied *you* is closer to a rounded rectangle
than a true oval. Its lid has beaklike pro-
jections extending from each end and ani-
mal heads centered on each side. Similarly
modeled heads are positioned below on
the body, and thread-relief lines encircle
the lid, body, and foot of the vessel, divid-
ing it into neat registers. Set on the long
axis, a swinging handle attaches to the
body with lugs capped by animal heads.
The minimal decoration of this *you* is sim-
ilar to the smooth, simple treatment of the
Huan *you* that is dated to the early West-
ern Zhou by scholars, who compare its
inscription to those on other vessels with
related phrases.[20]

This *you* is inscribed on the interior of
its lid and body. Although the inscription
on the body is partially obscured, it appar-
ently includes the same eight characters
that appear on the underside of the lid.
They read: "Bo made Wen Gui this pre-
cious sacrificial vessel [?]." The final char-
acter may be a clan symbol, apparently
represented by an arrow and quiver.

—R.Y.O.

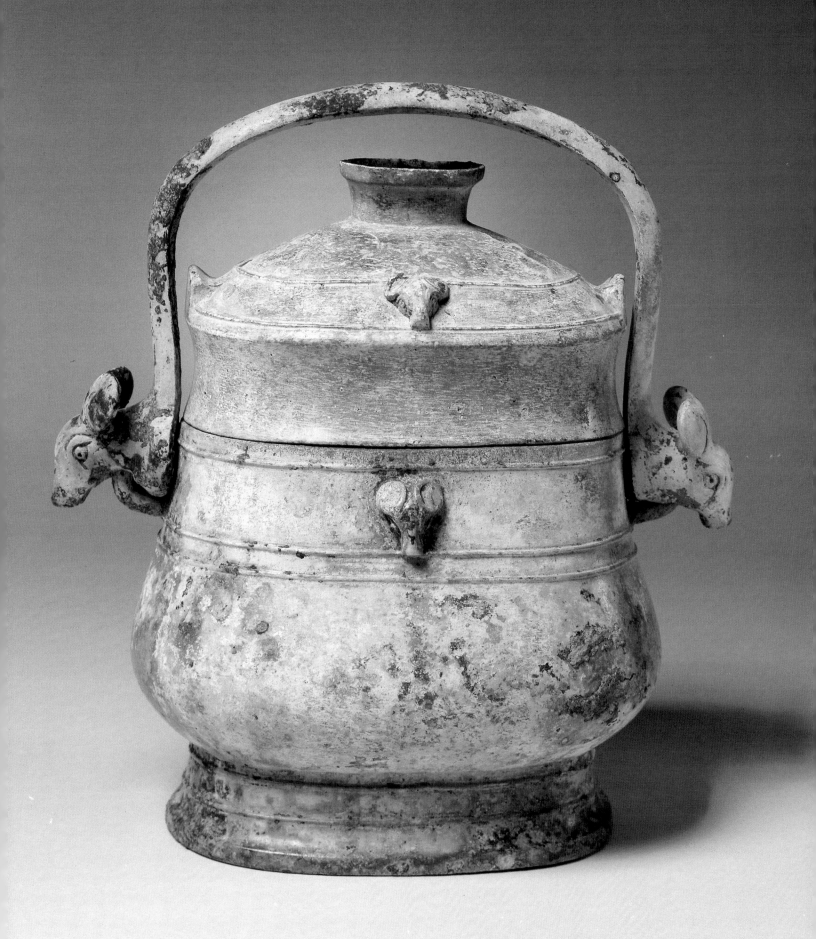

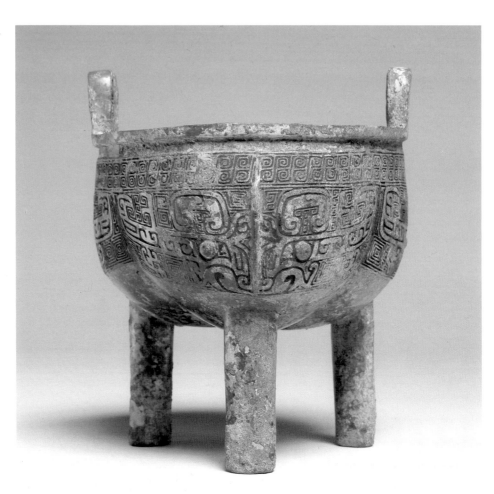

22. *Li ding*

Bronze, inscribed
Shang dynasty, 12th–11th century B.C.
H: 6 1/4 in. W (at mouth): 5 3/8 in.
560.1987

Ding are tripod vessels used for cooked food. Generally they have rounded bodies, but as here, they are sometimes lobed. The decorative schemes on lobed *ding* are similar to those on *li* vessels, which share their three-part configuration.[21] Each of this vessel's lobes is centered over a cylindrical leg. Two inverted U-shaped handles rise from the rim; they are set on a cross axis dividing the vessel approximately in half. The composition of this *li ding* is balanced by the relationship between its three lobes and two handles. Only one lobe is centered between the handles; the remaining two sections have a handle sitting over one half-side.

Each lobe of this *li ding* has a *taotie* face with lateral extensions representing a curved tail and claw. Except for their eyes and smooth central ridge, these *taotie* are flush with the *leiwen* spirals surrounding them and with the narrow band of barbed spirals beneath the rim. The wide ribbons representing the *taotie* are clearly distinguished from the background, and their C-shaped horns and tails are enhanced with intaglio linear details. The neck band beneath the everted lip continues the contour of the body rather than forming a recessed collar.

The arrangement of *taotie* faces on round-bodied *ding* vessels differs from their placement on trilobed *ding*. Rather than being centered over a leg, they span the arc between a pair of legs. In this respect, lobed *ding* are closer to tripod *li* vessels in their manner of decoration.[22]

Bronze *li* have ceramic prototypes from the Neolithic period. These are wide-mouthed vessels with hollow feet formed by joining together three pointed lobes of clay. A preference for ceramic *li* continued into the Shang and early Zhou periods when bronze casting was fully developed. The bodies of bronze *li* from tombs of the Erligang period at Zhengzhou in Henan and Panlongcheng in Hubei lack the articulated recessed neck of later, more advanced bronze vessels.[23]

An inscription of two characters appears on the interior of this *li ding*, within the lobe centered between the two handles. It includes *mu* (tree, wood) and a character that is most likely a form of Yin, the name of the dynasty (or tribute, offering).[24]

—R.Y.O.

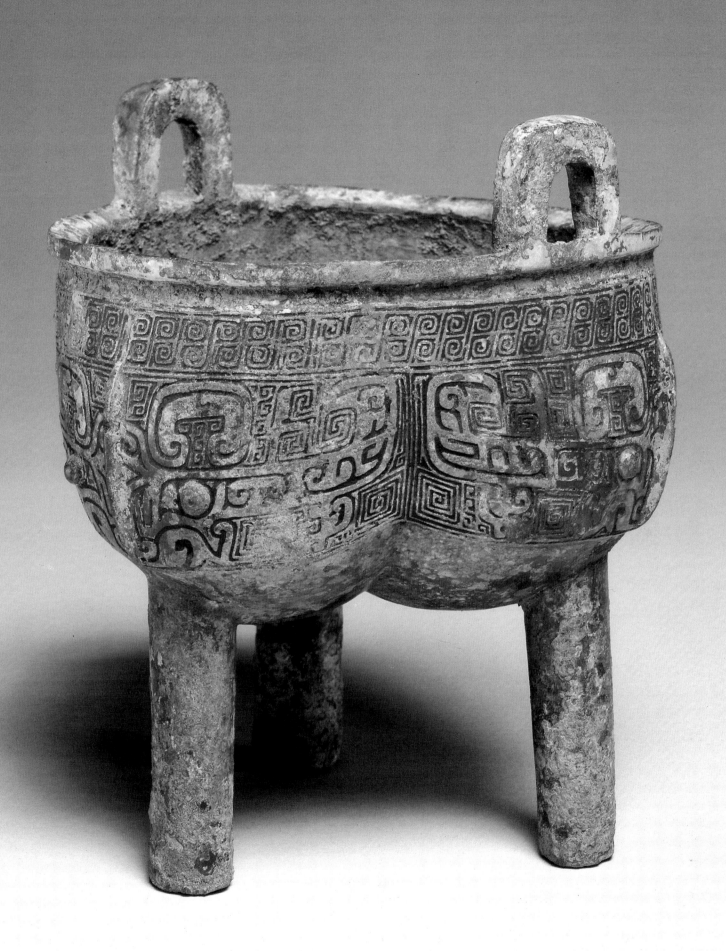

23. *Fang ding*

Bronze, inscribed
Shang or early Western Zhou dynasty,
11th century B.C.
H: 7 3/4 in. W: 6 7/8 in. D: 5 in.
479.1987

Standing on four columnar legs, this *fang ding* has a rectangular body with sides that flare gradually to an everted lip. Two inverted U-shaped handles rise from its flat rim on the narrow ends. At its corners the vessel has blunt flanges that are scored with alternating T-patterns and straight lines. Each of its exterior faces consists of a plain rectangular panel enclosed by a frieze with dragons above and rows of bosses below and to the sides. Aligned in rows of three, the rounded bosses vary in number from wall to wall. The wide ends have seventy-five and seventy-eight elements; the narrow, sixty and sixty-three.

The horizontal friezes have pairs of beaked dragons facing toward a central shieldlike element.[25] Shown in profile, the dragons have hooked heads with prominent eyes and small C-shaped horns. Their elongated bodies terminate in coiled, upturned tails. Those on the wider sides of the vessel have horizontal extensions on their tails with downward, double-hooked appendages.

Slightly tapered at the middle, each leg is surmounted by a *taotie* face with a bisecting flange. Below the faces are two thread-relief lines that partially encircle the leg until they are interrupted by casting seams. These seams adjoin double ridges that crisscross the underside of the vessel between its legs. Examinations of similar *fang ding* reveal that they were cast with a four-piece outer mold and an inter-leg core assembly.[26] On an interior wall of this *fang ding* is a seven-character inscription: "Shu made Dan Gong this precious sacrificial vessel." Identification of the first character is not certain, however, as it is abraded and hard to read.

The *fang ding* is most likely the oldest rectangular vessel form in China. Erlitou ceramics and bronzes from the Erligang period preserve its shape.[27] *Fang ding* are commonly decorated with triple rows of bosses, but usually their horizontal friezes have double-bodied snakes rather than paired dragons. A different approach to decorating *fang ding* originated in the Anyang period, when *taotie* faces appeared on the four sides. Vessels of this type often have paired dragons in their upper frieze, as does the She *fang ding* in the Nelson-Atkins Museum of Art, Kansas City.[28] The horizontal frieze over a *taotie* is another option that was sometimes eliminated (see fig. 23a).　　　—R.Y.O.

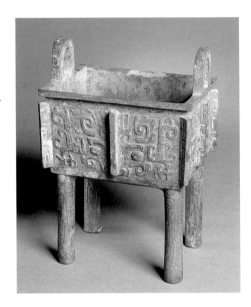

23a. *Fang ding*

Bronze, inscribed
Shang or early Western Zhou dynasty,
11th century B.C.
H: 9 1/8 in. W: 6 3/4 in. D: 5 1/4 in.
225.1989

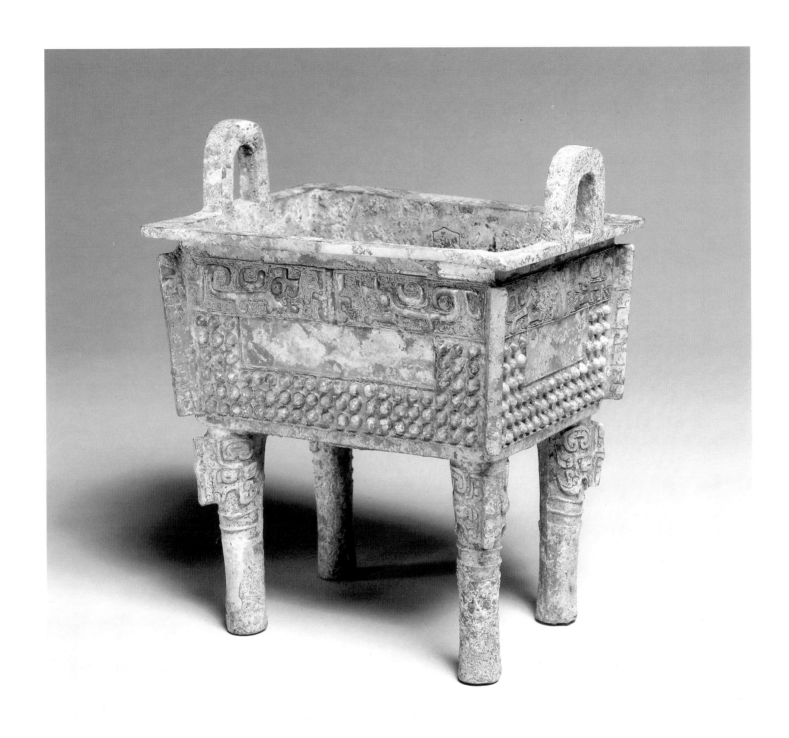

24. Gui

Bronze, inscribed
Western Zhou dynasty, 10th century B.C.
H: 5 3/4 in.
471.1987

Large plumed birds appear as the principal design on many Western Zhou bronze vessels.[29] This elliptical *gui* has a pair of bird-shaped handles set on its shorter axis, and four large birds dominate its body, dividing it into quadrants. These birds turn their plumed heads backwards, facing their tails and the vessel's handles. Unlike many bird-decorated *gui*, this example has no frieze around its neck; its birds extend from foot to neck in a single band.[30] An eye-and-scroll pattern decorates its foot ring, and raised crisscross lines appear on its underside.

At its bottom interior, the vessel has an inscription aligned on the long axis, which translates, "made this precious *gui*." It corresponds to the final three characters in the longer inscriptions on two bird-decorated *gui* from tomb M17 at Changan Huayuan cun in Shaanxi. These two *gui* were probably made during or soon after the reign of Zhao Wang under his successor Mu Wang, since their inscriptions mention a southern military campaign against the Chu and Jing, during which Zhao Wang is believed to have died (ca. 975 B.C.).[31]

Used for offering food, *gui* from the Shang dynasty often lack handles and are sometimes termed *yu*. From the late Shang throughout the Zhou, *gui* have two C-shaped handles embellished with the heads of animals or birds. The time span during which large birds appear as dominant motifs on *gui* and other rounded vessels is relatively short. They disappeared when certain types of wine vessels (*jue, you,* and cylindrical *zun*) ceased being used. A *gui* in the Arthur M. Sackler Gallery, Smithsonian Institution, has bird elements similar to those appearing on this bronze.[32]
— R.Y.O.

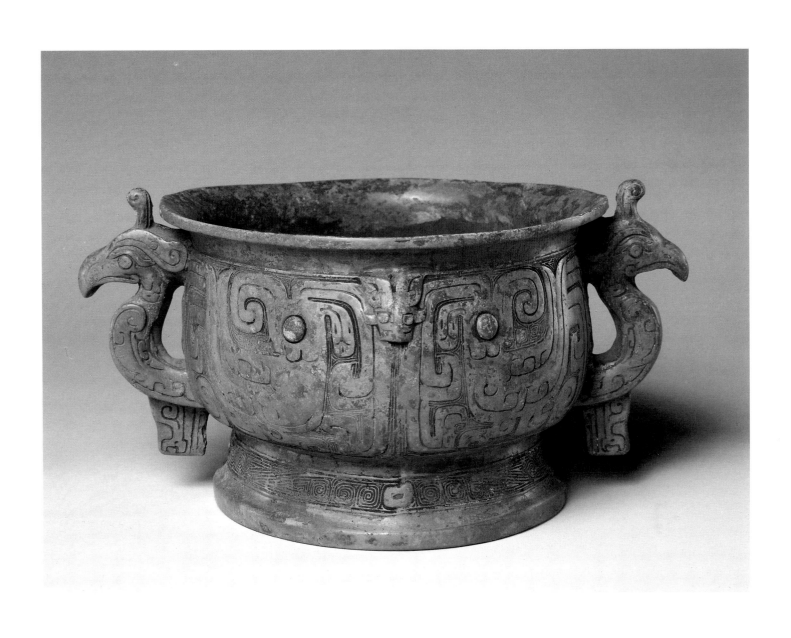

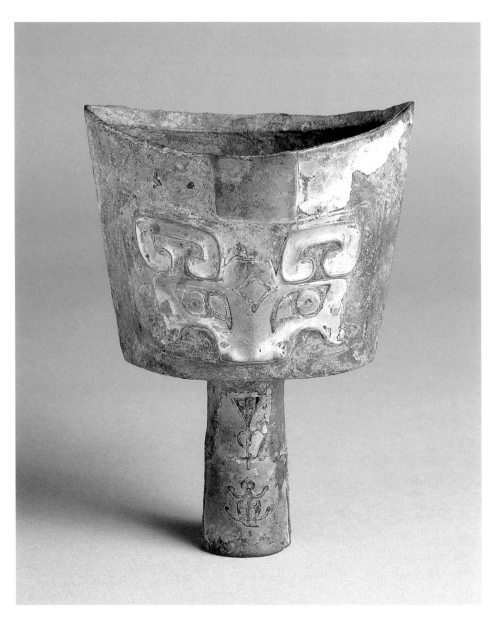

25. *Nao*

Bronze, inscribed
Shang dynasty, Anyang period,
12th–11th century B.C.
H: 5 ¼ in.
482.1987

In China various types of bronze bells are distinguished by different names. A *nao* stands on a tubular shaft with its mouth facing upward. Lacking a clapper, it is struck on the exterior to create a sound. Shang dynasty *nao* bells with *taotie* faces have been excavated at Anyang, and the height of this *nao* falls within their general range of measurements.[33]

The cross section of this bell is a pointed ellipse. Its hollow shank opens into a flat base from which the sides flare to an open mouth with curved rim. *Taotie* with C-shaped horns appear on each side of the bell; they are set against a plain ground and isolated within a trapezoidal panel. Although the jaws of the *taotie* are clearly indicated, there is no representation of a body on either side of the face. Centered above each *taotie* is an undifferentiated quadrangular area.

A two-character inscription appears on the shaft, an intaglio *shen* (body) and *gui* (tortoise).[34] Besides inscribed shanks, some *nao* have interior inscriptions; three bells from Anyang Dasikong cun have a single character at the center of an inner wall, just below the lip.[35]

With one known exception, *nao* seem to have disappeared from Henan after the Anyang period. The lone exception is a bell with a loop on its shaft that was discovered in an early Western Zhou tomb at Baoji Zhuyuangou.[36] The popularity of *nao* persisted in southern China, where extremely large examples survive. Although the origin of *nao* bells remains uncertain, *nao* from Henan probably served as prototypes for those from the south.[37]

—R.Y.O.

Notes

1. Robert W. Bagley, *Shang Ritual Bronzes in the Arthur M. Sackler Collections*, vol. 1 of *Ancient Chinese Bronzes in the Arthur M. Sackler Collections* (Washington, D.C., and Cambridge: Arthur M. Sackler Foundation and Arthur M. Sackler Museum, Harvard University, 1987), figs. 35 and 45.

2. Robert W. Bagley, "Shang Ritual Bronzes: Casting Technique and Vessel Design," *Archives of Asian Art* 43 (1990), pp. 10–11, 14.

3. Jessica Rawson and Emma Bunker, *Ancient Chinese and Ordos Bronzes* (Hong Kong: Oriental Ceramic Society of Hong Kong and the Urban Council of Hong Kong, 1990), p. 64.

4. See Bagley, *Shang Ritual Bronzes*, pp. 15–16; Robert W. Bagley, "The Beginnings of the Bronze Age: The Erlitou Culture Period," in *The Great Bronze Age of China*, ed. Wen Fong (New York: Metropolitan Museum of Art and Alfred A. Knopf, 1980), pp. 74–75; Noel Barnard, "Wrought Metal-Working Prior to Middle Shang (?)—A Problem in Archaeological and Art-Historical Research Approaches," *Early China*, 1980–81, no. 6, pp. 12–16; and W. Thomas Chase, *Ancient Chinese Bronze Art: Casting the Precious Sacral Vessel* (New York: China Institute in America, 1991), pp. 41–42.

5. Rawson and Bunker, *Ancient Chinese and Ordos Bronzes*, p. 116, pl. 29. The heights of the two *jiao* are 16.9 cm and 17.1 cm; a pair of *gu*, a cylindrical *zun*, a *fang ding*, and a *gui* are also in this group.

6. See Jessica Rawson, *Western Zhou Ritual Bronzes in the Arthur M. Sackler Collections*, vol. 2A of *Ancient Chinese Bronzes in the Arthur M. Sackler Collections* (1990), pp. 98–99, fig. 142; and Cheng Changxin, Qu Delong, and Jiang Dongfang, "Beijing jianxuan yizu ershibajian Shang daidai mingtong qi" (Twenty-eight inscribed Shang dynasty bronzes from Beijing), *Wenwu*, 1982, no. 9, pp. 34–35.

7. Rawson, *Western Zhou Ritual Bronzes*, vol. 2A, pp. 96–98.

8. Ibid., vol. 2B, p. 221.

9. Rawson and Bunker, *Ancient Chinese and Ordos Bronzes*, p. 80.

10. See Li Chi and Wan Chia-pao, *Studies of the Bronze Ku-Beaker*, Archaeologia Sinica, n.s., no. 1 (Nankang, Taiwan: Academia Sinica, 1964), pls. 32–33; Robert L. Thorp and Virginia Bower, *Spirit and Ritual: The Morse Collection of Ancient Chinese Art* (New York: Metropolitan Museum of Art, 1982), p. 24, no. 8 and frontispiece; Jan Fontein and Tung Wu, *Unearthing China's Past* (Boston: Museum of Fine Arts, 1973), p. 38, no. 8; Howard A. Link, "Curator's Choice: Robust Bronzes of the Honolulu Academy of Art," *Orientations* 5, no. 11 (Nov. 1974), pp. 39–40, fig. 17; and Bernhard Karlgren, *A Catalogue of Bronzes in the Alfred F. Pillsbury Collection* (Minneapolis: Minneapolis Institute of Arts, 1952), no. 25.

11. Bagley, *Shang Ritual Bronzes*, pp. 310–11, no. 50.

12. Hayashi Minao, "In Shū seidōki meimon chūzō hō ni kansuru jakkan no mondai" (Notes on the method of casting inscriptions on Yin and Zhou bronzes), *Tōhō Gakuhō* 51 (Mar. 1979), pp. 1–58.

13. Bagley, *Shang Ritual Bronzes*, pp. 292–94, no. 49.

14. Jessica Rawson, *Chinese Bronzes: Art and Ritual* (London: Trustees of the British Museum and Sainsbury Centre for Visual Arts, University of East Anglia, 1987), pp. 61–62.

15. Bagley, *Shang Ritual Bronzes*, pp. 342–43, fig. 58.1.

16. Ibid., pp. 346–47, no. 59.

17. A *hu* and other vessels in the Arthur M. Sackler Gallery, Smithsonian Institution, retain impressions of woven textiles or matting on their surface. See ibid., p. 347, no. 59 *hu*; p. 191, no. 16 *jue*; p. 259, no. 40 *gu*; p. 277, no. 44 *zun*; p. 289, no. 48 *zun*. The cloth itself is preserved on a *fang ding*, p. 473, no. 88. The Freer Gallery of Art has a *zun* (acc. no. 44.1) with vestiges of a weave pattern retained from early contact with fabric; see John Alexander Pope, Rutherford John Gettens, James Cahill, and Noel Barnard, *The Freer Chinese Bronzes*, vol. 1, Freer Gallery of Art Oriental Studies no. 7 (Washington, D.C.: Smithsonian Institution, 1967), pp. 87–88, fig. 10.

18. See Bagley, *Shang Ritual Bronzes*, pp. 342–45; and Rawson, *Western Zhou Ritual Bronzes*, vol. 2B, pp. 480–81.

19. See Annette L. Juliano, *Bronze, Clay and Stone: Chinese Art in the C. C. Wang Family Collection* (Seattle: University of Washington Press, 1988), no. 6; and Rawson, *Western Zhou Ritual Bronzes*, vol. 2A, pp. 67–68.

20. Rawson, *Western Zhou Ritual Bronzes*, vol. 2B, p. 517, fig. 72.3.

21. "*Li ding*" is a hybrid term used in Western writing to denote lobed vessels that stand somewhere between a *li* and a round *ding*; see Bagley, *Shang Ritual Bronzes*, p. 481.

22. Ibid.

23. Rawson, *Chinese Bronzes*, pp. 60–61.

24. I am grateful to Dr. S. P. Kiang for his assistance in reading this inscription.

25. This motif originated as the nose of a *taotie*; see Bagley, *Shang Ritual Bronzes*, p. 463.

26. Chase, *Ancient Chinese Bronze Art*, pp. 24–25, figs. 1–2.

27. Bagley, *Shang Ritual Bronzes*, p. 474; and Rawson, *Chinese Bronzes*, p. 66.

28. Bagley, *Shang Ritual Bronzes*, p. 475, fig. 88.3.

29. See Rawson, *Western Zhou Ritual Bronzes*, vol. 2A, pp. 75–83.

30. Other examples include the lidded Zhong *gui* from Shaanxi Fufeng Famen Gongshe, and the Meng *gui* from Shaanxi Chang'an Zhangjiapo, which has an attached square base; see ibid., vol. 2A, figs. 108 and 111.

31. Ibid., vol. 2A, p. 74.

32. Ibid., vol. 2B, pp. 430–31, no. 54.

33. Chen Fang-mei, "The Stylistic Development of Shang and Zhou Bronze Bells," trans. Rob Linrothe, in *Style in the East Asian Tradition*, ed. R. Scott and G. Hutt, Colloquies on Art and Archaeology in Asia, no. 14 (London: Percival David Foundation of Chinese Art, 1987), p. 19, pl. 1, illustrates four *nao* from Anyang Tomb 1083; they measure 12.5 cm to 16.7 cm in height. Three inscribed bells excavated in 1953 from Anyang Dasikong cun M312 are 18.6 cm, 15.8 cm, and 13.9 cm high; see Rawson, *Western Zhou Ritual Bronzes*, vol. 2B, p. 728, fig. 123.1.

34. I am grateful to Dr. S. P. Kiang for his assistance in reading this inscription.

35. Hayashi Minao, *In Shū jidai seidōki soran ichi* (Conspectus of Yin and Zhou bronzes I), vol. 1 of *In Shū jidai seidōki no kenkyū* (Study of Yin and Zhou bronzes) (Tokyo: Yoshikawa Kōbunkan, 1984), p. 390; and Li Xueqin, ed., *Qingtongqi* (Bronzes), pt. 1, *Gongyi meishu bian* (Crafts section), vol. 4 of *Zhongguo meishu quanji* (Complete collection of Chinese art) (Beijing: Wenwu Press, 1985), pp. 18, 48, pl. 52.

36. Rawson and Bunker, *Ancient Chinese and Ordos Bronzes*, p. 146.

37. Rawson, *Western Zhou Ritual Bronzes*, vol. 2B, p. 727.

Warring States and Han Dynasty

26. Jar

Stoneware
Warring States, 475–221 B.C.
H: 14 1/2 in. D: 16 1/8 in.
324.1987

Imposing in its large, full shape, this gray stoneware jar exemplifies the finest of the Warring States ceramic form. Rising from a flat, untrimmed foot, the vessel gradually swells to a robust girth greater than its height. The shoulder slopes gently and curves inward to meet a constricted neck topped by an everted lip that has been flattened across the top and then wheel-turned ever so slightly on the interior. The exterior is stamped repeatedly, from within a few inches of the base to within four inches of the lip, in an orderly inch-wide comb pattern. The combing consists of a deeply impressed horizontal band across the top, followed underneath by a rigid, seven-pronged vertical pattern. The gray clay is dense and fine, permitting a sharp, crisp impression on the surface. The evenness of the body color may be attributable to the same process of imbibing that has been described as belonging to the Shang ceramic tradition.[1] In addition the surface has been lightly burnished, lending a soft glow to the gray color.

The Sze Hong vessel was clearly coil-built; a number of its body sections have been luted together. By running a hand against the interior, one can feel the ridges of separate construction that have been smoothed by the potter. Small indentations on the interior surface correspond to the impression of human fingers, while section joints can be discerned by the slightly rougher texture of the clay at the join. The top, unadorned portion of the vessel reveals a more even construction and was most likely added to the main body by a wheel-thrown process. The vessel rings when struck, indicating a relatively high-fire process estimated at 1200 degrees C.[2]

Warring States kiln sites have yielded a number of ceramic wares including porcelaneous stoneware and early glazed wares. The only two major kiln sites containing both are Shouchou in Anhui and Shaoxing in Zhejiang. Findings at Shaoxing include large vessels with shapes and decoration very similar to the Sze Hong jar.[3] Shaoxing finds also have stamped impressed designs of great clarity with specific motifs belonging exclusively to this site.

—J.M.W.

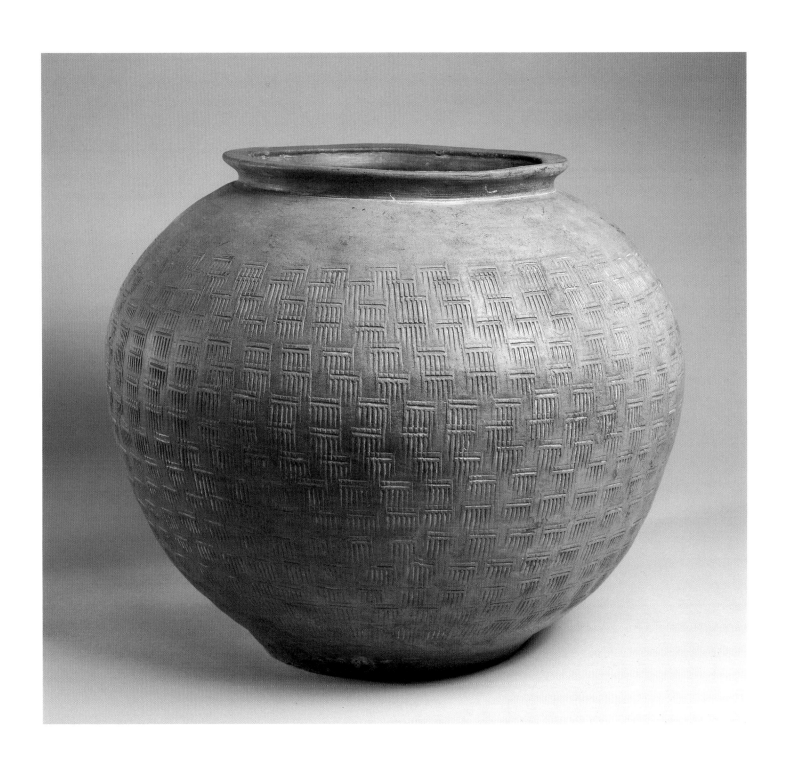

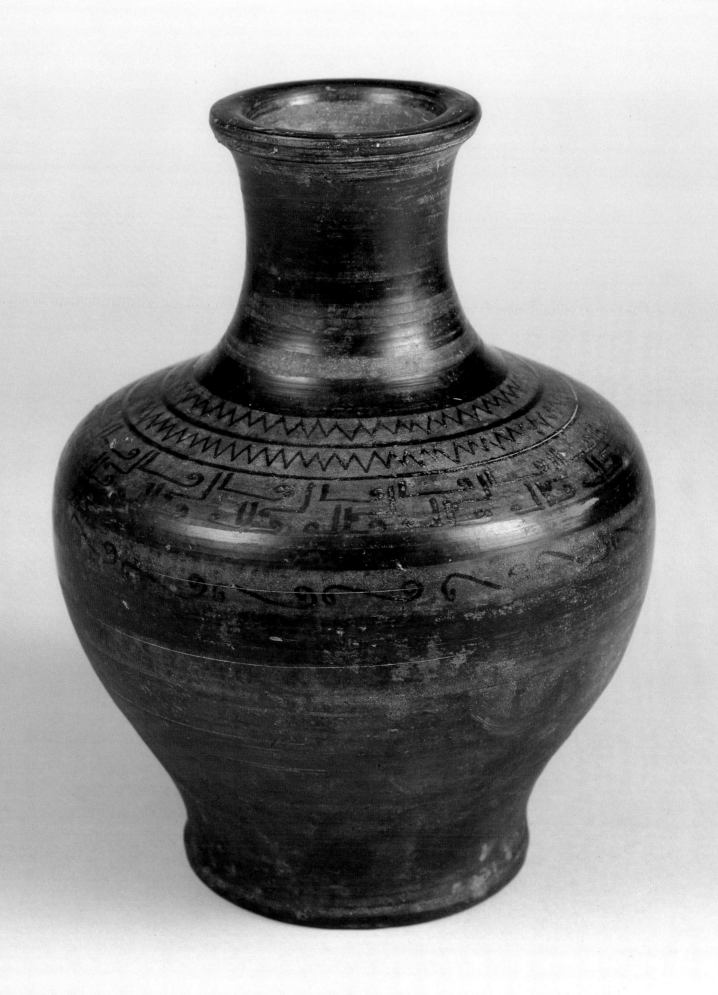

27. Jar

Earthenware, Huixian type
Eastern Zhou or Warring States,
5th–4th century B.C.
H: 7 1/2 in. D: 6 in.
550.1987

Completely flat at the base and with a slightly thicker lower portion, this small jar rises to a well-articulated shoulder and constricted, high neck topped with a rounded lip. All evidence, including the ring marks apparent on the base and the evenness of the body, indicates that the vase was wheel-thrown, very likely in one piece. Although the base lacks a true foot, its exterior has been slightly trimmed, as has the lip. Horizontal markings on the main body of the vessel indicate some trimming as well. The hard earthenware body has been exposed to reduction firing, resulting in the black body color.[4] Jars of this shape are typically referred to as wine vessels.

The surface decoration on the jar consists of two parallel horizontal bands of zigzag lines around the upper portion of its shoulder. Directly below the bands is a wide decorative panel that includes intersecting lines resembling a stylized *leiwen* pattern. Below is a plain band of finely burnished surface, followed by a horizontal scrolling design. The patterns are all etched into the surface of the vessel by a technique that has been described by Walter Hochstader as a "graphite" decoration.[5]

Simple, elegant, decorated vessels of this type have been found at Huixian, Honan, where both bronze and ceramic material from the Shang and Zhou are in evidence.[6] Hochstader defines the various types of pottery found at Huixian and further refines his analysis of this type of graphite decoration as "only present on a particular type of pottery from Loyang."[7]

—J.M.W.

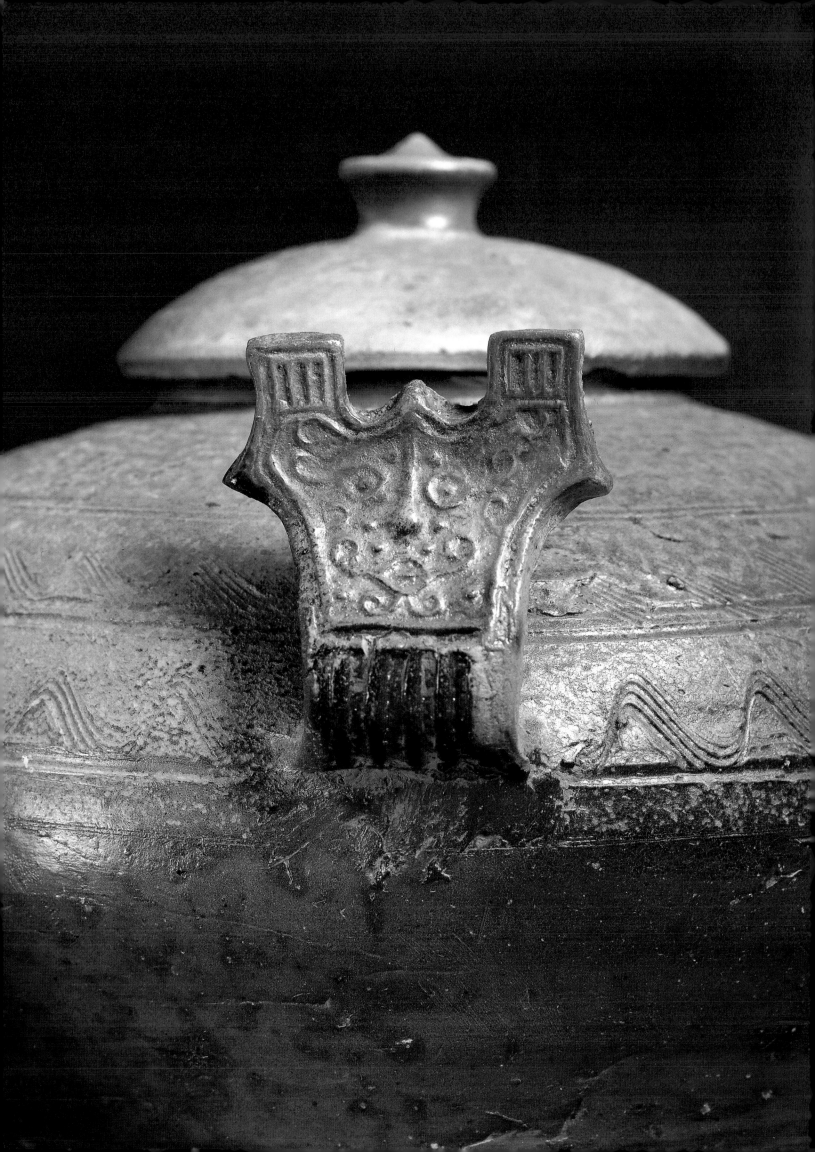

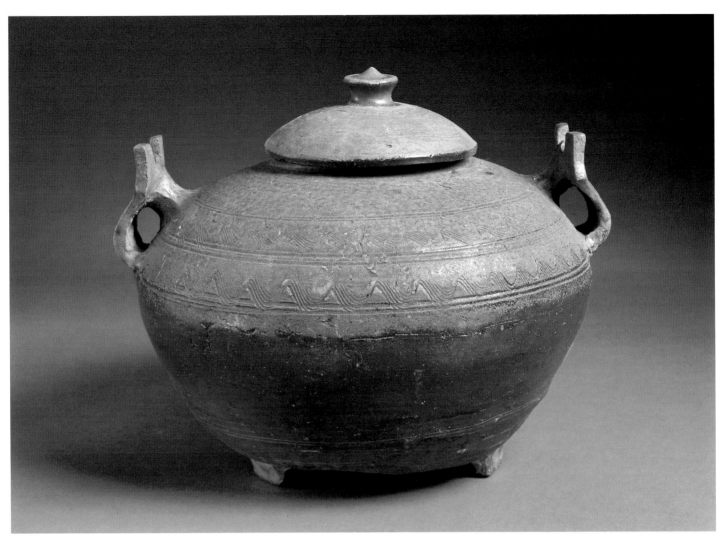

28. Jar

Stoneware with greenish glaze
Western Han dynasty, 2nd century B.C.
H: 9 3/8 in. D: 11 5/8 in.
42.1990

Exhibiting a wide-bodied profile with a gently sloping shoulder, this vessel tapers to a narrow base resting on three flat feet that are attached at equal intervals around the perimeter of the base. The mouth is small, with straight sides forming the lip, and is topped with a domed lid crowned by a small knob-handle. Two handles protrude from either side of the vessel's shoulder. The base of each handle is attached by two armatures luted to the body. The armatures swell outward and upward, forming a flat, broad surface that has been adorned with raised masklike markings (see detail). Earlike projections rise upward from the flat face at the uppermost ends.

The surface of the body is decorated around the vessel's shoulder with three sets of deeply incised horizontal lines that begin at the top of the handle and end approximately at the waist of the vessel. The paired lines create two panels that have been decorated with a free-flowing combed design, which occasionally breaks into the horizontal banding. This spontaneous design is clearly hand-incised, with no evidence of stamping. The top portion of the vessel is covered in a thin, light-green glaze that appears, from the uneven lower edge, to have been applied by dipping. The lower portion of the vessel is undecorated save for a thin double line of inscribed horizontal banding in the last inch above the base. From the shoulder down, the vessel is unglazed, with only its dark brown, fire-burned body showing through.

Vessels of this type have been found in sites ranging along the east-central portions of Han dynasty China.[8] Yutaka Mino lists no fewer than three vessels that bear striking resemblance to the Sze Hong piece.[9] All are marked with the same type of free-form incised design, and all belong to that form described as *pou*, with three raised feet, strong, highly patterned S-shaped handles, and a relatively small mouth topped by a domed lid. Of those excavated, the ones from Kuishan, Xuzhou, and Fenghuanghe, Jiangdu, bear the greatest resemblance to the Sze Hong piece.

Certain aspects of this jar—the crisp lines, the strong flangelike handles and their ornamentation—remind one of bronze working. There is only limited evidence of a similar vessel in metal, however, and it reportedly comes from Korea.[10] The general shape described as *pou* does not last into the Jin period as a ceramic vessel. What is more important, perhaps, is the role this finely made vessel plays in the transition between early stoneware glaze-firing and the more sophisticated so-called proto-*yue* forms of the Jin-period wares. It is not clear whether this type of vessel was exclusively mortuary or also had an everyday functional use.

—J.M.W.

Detail, cat. no. 28.

29. *Hu*

Earthenware with mineral pigments
Han dynasty, 206 B.C.–A.D. 220
H: 20 in. D: 12 5/8 in.
304.1987

A large and finely potted vessel with lid, this *hu* rests on a high foot ring that is accentuated by strong horizontal banding. The base is narrow and constricted, but it quickly blossoms into a fully rounded body marked by two horizontal bands and two opposing handles on the shoulder, which gradually narrows to a long neck with a thick, banded lip. The lid is gently domed.

Made of a grayish earthenware, the vessel shows evidence of having been fired and then painted with a variety of bright colors including a predominant ocher and some reddish orange and white, with highlighting in a purplish tone, all done on a black ground. The lively painted designs, probably executed with a brush, are abstract motifs typical of the Han period and are also seen in lacquers, paintings, and other vessels.[11] The two handles, raised and appliquéd onto the shoulder, are highlighted in the same vivid ocher color, as are the horizontal bandings mentioned above. Traces of organic material within the vessel and across the sides indicate that the object was buried, while the fragile pigments used in the painting indicate it was probably intended only for burial use. —J.M.W.

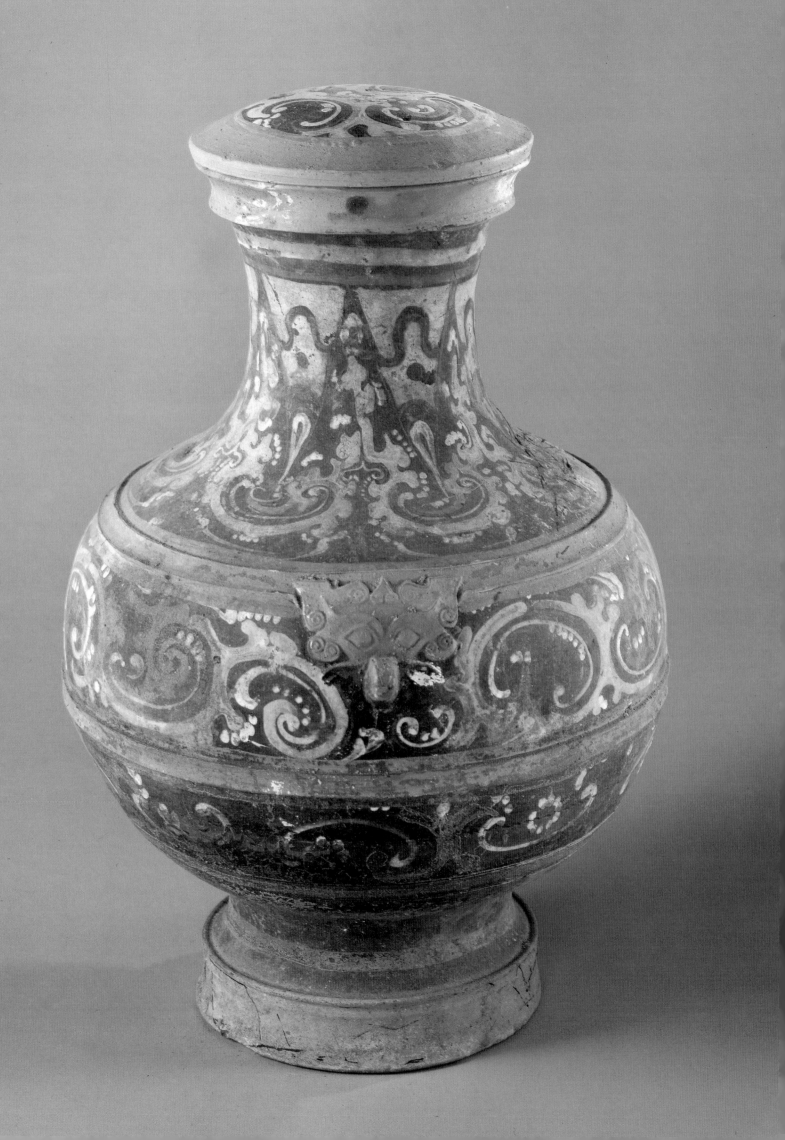

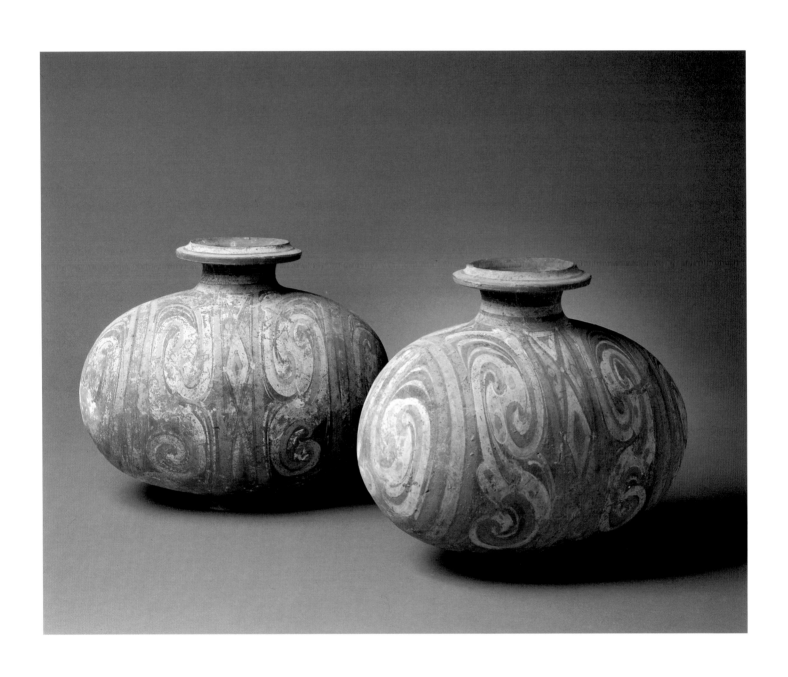

Warring States and Han

30. Pair of flasks

Earthenware with mineral pigments
Western Han, ca. late 3rd–1st
century B.C.
H: 10¼ in. W: 13 in. D: 7½ in. (each)
305.1987.1–.2

Ovoid in shape, resting on short foot
rings, the bulbous bodies of these flasks
are topped with narrow necks and widely
flared, turned lips that project upward at
the mouth. Constructed of a fine-grained
gray earthenware, the flasks are typical of
hard-bodied Qin and Western Han wares
which have been proven to have been fired
at a temperature above 1000 degrees C.
Surface decoration consists of vertical band-
ings of red mineral pigment alternating
with swirling cloud patterns in white and
red pigment that was applied after firing,
creating a flaking and powdery surface.

Although it is difficult to say precisely
how this shape was formed, it seems clear
that the vessel was thrown on the wheel
in segments and later joined to form this
unique shape, variously called a "silk-
worm cocoon-shaped flask"[12] and a
"duck-egg jar."[13] The shape evolved from
the late Warring States period, reaching
the height of its popularity in the Western
Han period but generally dying out by the
middle of the Western Han.[14] In a tomb
opened in 1973 in Tongshan xian, Jiangsu
province, twelve lidded vessels of this
type were reported to have been found.

This tomb is dated to the early part of the
Western Han.[15] All vessels of this type are
from tombs, indicating a ritual rather than
everyday use. Another vessel from the Sze
Hong collection (fig. 30a) is unpainted but
decorated with simple, incised vertical
banding. An unpainted vessel very much
like the Sze Hong vessels was found in
Dali xian, Shaanxi province, and indicates
the popularity of the shape in the early
Western Han.[16] —J.M.W.

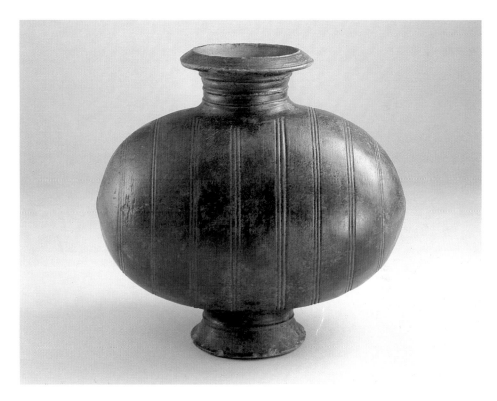

30a. **Flask**
Earthenware
Western Han, ca. late 3rd–1st
century B.C.
H: 10 in. W: 10 in. D: 7¼ in.
163.1989

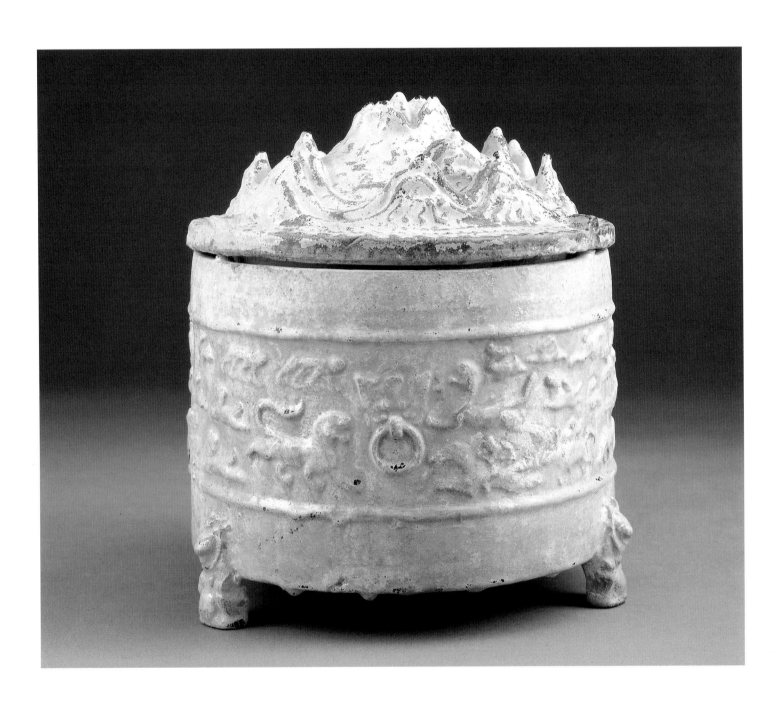

31. **Hill jar**
Earthenware with lead glaze
Han dynasty, 206 B.C.–A.D. 220
H: 8⁵/₈ in. D: 7³/₄ in.
56.1989

Flat-bottomed and resting on three feet in the form of bears, this round jar with lid is constructed of a reddish earthenware that has been covered with a thick green glaze. The lid, domed and in the shape of well-articulated peaks, rests on the lip at three points that are clearly spur marks where the lid had rested upside-down during firing. Small spur marks are also evident on the rim of the lid's top in exactly the same position, confirming that the two pieces belong together. The container shows evidence of being wheel-thrown, with molding and appliqué decoration added to the body and the lid. The three bear-shaped feet show signs of having been luted to the body.

The green glaze that completely covers the vessel inside and out is of a kind commonly seen in Han mortuary ceramics. The glaze components, copper with lead oxide as the principle fluxing agent, produce the green color when fired in an oxidizing atmosphere. Droplets of glaze

adhere to the base and across the tops of the peaks, attesting to its viscosity. The iridescent color of the glaze is a result of contact with moisture in the tomb. It seems likely that lead glaze was used exclusively for burial items; examples have been found primarily in burial sites. There is some debate as to the origin of this thick, low-fired glaze. Some scholars argue that a western Asian influence brought about its use in the Western Han period.[17] It is clear that this type of soft glaze applied to a soft body enjoyed great popularity during the Han period; it was revived in the Tang period.

The molded relief decoration represents a favorite Han hunting theme: a rider on horseback and various birds and animals, all depicted in sharp profile around the body of the vessel.[18] The lid, formed in the shape of mountain peaks and surrounded by waves, gives this type of vessel its name, "hill jar." It is thought that the mountain peaks are meant to call to mind the mythical island of Penglai, realm of the Immortals.

Fig. 31a illustrates another example of this type of ware in the Sze Hong collection. —J.M.W.

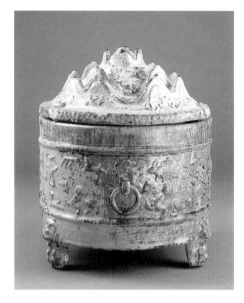

31a. **Hill jar**
Earthenware with lead glaze
Han dynasty, 206 B.C.–A.D. 220
H: 9¹/₂ in. D: 7⁷/₈ in.
56.1989

32. Incense burner

Bronze, not inscribed
Eastern Han, A.D. 25–220
H: 9 1/2 in. D: 8 1/4 in.
88.1989

A flat-bottomed basin with everted lip is
the base for a long-stemmed bowl topped
by a pierced lid that ends in a sharp point.
The foot of the stemmed bowl is deco-
rated with a swirling pattern reaching
onto the stem. The stem is marked by
a central horizontal ring and banded by
three horizontal rings near the base of the
bowl. The bowl is undecorated; the lid is
etched in swirling vertical patterns resem-
bling organic forms. The patina is a rich
blue-green with some dark brown show-
ing overall.

This kind of vessel or incense burner,
frequently called a *boshanlu*, is thought to
have been an invention of the Han period.
Laufer describes the invention as having
come from a need for incense burners
once the Han people came to use frankin-
cense, a foreign import.[19] Han use of in-
cense ranged from ritual purposes to the
more basic property of perfuming the air
and clothes with the fragrant smoke. The
pierced mountainlike lid permitted the
smoke to escape from the holes. The form
is clearly related to the hill jar. The plate
has been described as an area to catch ash
or a reservoir for water.

Bronze working was widespread by
the Han period; foundries ranged from
north to south, and evidence of bronze
objects appeared in most royal tombs of
the period.[20] Plain and relatively spartan,
this censer admirably exhibits the simple
and clean lines adopted during the Han
period.

Censers were also made of soft earth-
enware and covered with a lead glaze
(fig. 32a). These are considered to be a
less expensive product used exclusively
as grave goods; they are directly linked
to a metal prototype. —J.M.W.

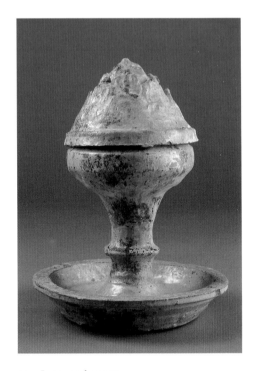

32a. **Incense burner**
Earthenware with lead glaze
Eastern Han, A.D. 25–220
H: 9 1/2 in. D: 6 1/2 in.
291.1987

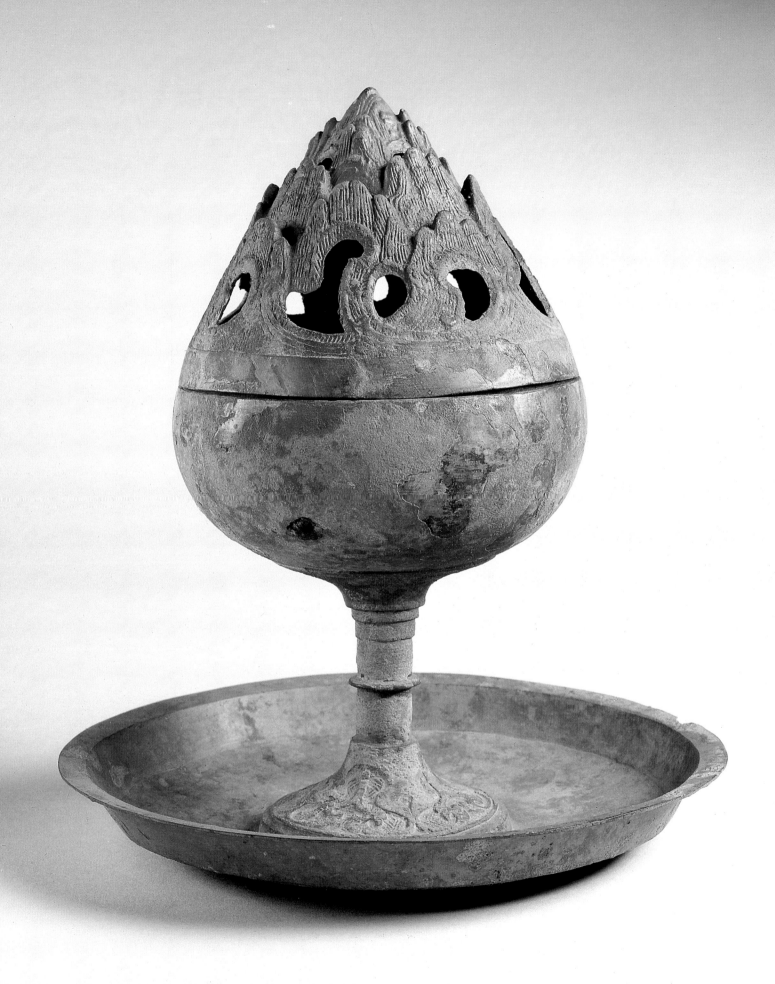

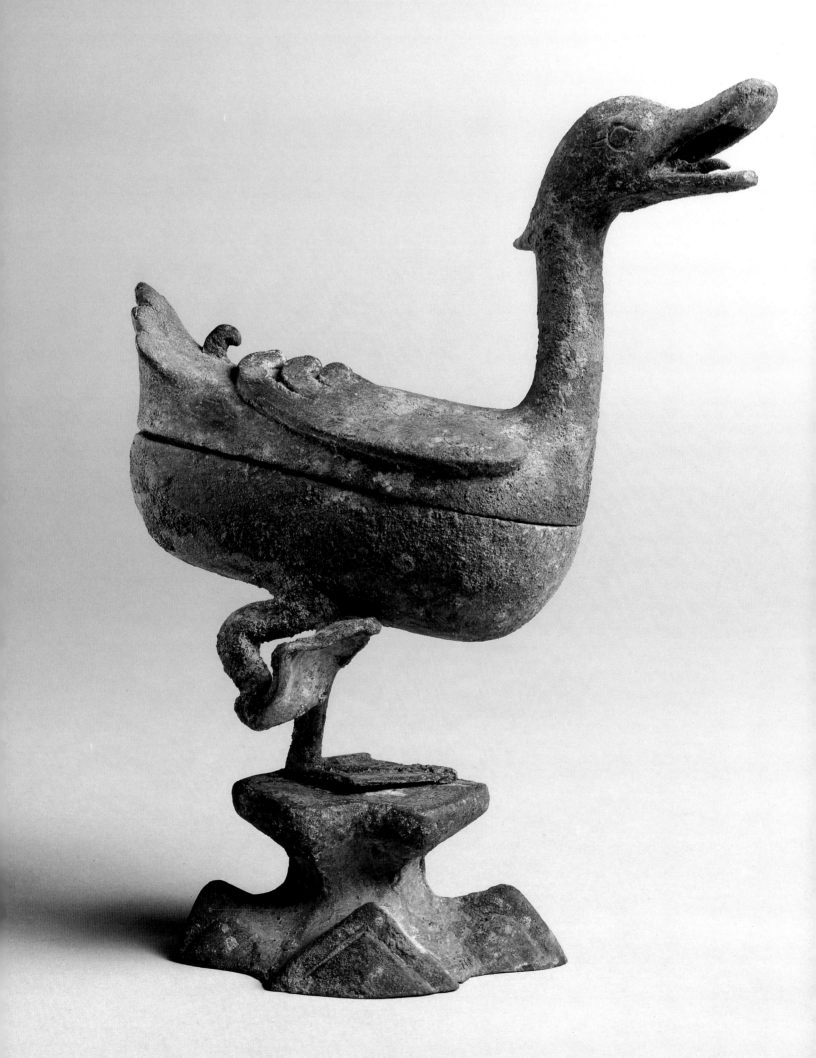

33. Striding duck

Bronze, not inscribed
Han dynasty, 206 B.C.–A.D. 220
H: 7 5/8 in. W: 6 in. D: 2 3/8 in.
468.1987

Standing securely on one foot, the other
raised in enthusiastic anticipation of a sure
stride forward, this animated image of
a duck may have served as a lamp or a
censer during the Han period. The sculp-
ture consists of two separate forms: the
rocklike form of the base with the attached
legs and bowl of the lower body, and the
separate upper portion resembling a duck
with wings folded back, which lifts off of
the lower part, like a lid. The bird's head
is cocked playfully to one side, its tongue
protruding slightly. Its long, graceful neck
is hollow. There is a slight notch a third of
the way down from the top of the head
along the back of the neck. Across the
duck's back two stylized folded wings end
in three curved, featherlike protrusions.

Lamps occur frequently in Han dy-
nasty tombs, often in the shape of animals.
Birds seem to have been favorite forms for
lamps, although very fine examples in the
shape of other animals are known.[21] Most
of them show a hinged lid that folds out
to form the bowl of the lamp. In the case
of the Sze Hong duck, it appears that a
wick could have been threaded through
the neck, and the mouth thus would have
functioned as the light source. It may be,
however, that this image is more closely
associated with a censer, and the neck and
mouth would have acted as a chimney for
the fragrant smoke. —J.M.W.

34. Pair of square *hu*

Bronze, not inscribed
Han dynasty, 206 B.C.–A.D. 220
H: 17 in. D: 8 1/4 in. (50.1990.1)
H: 17 in. D: 8 1/8 in. (51.1990.2)

These tall bronze wine containers with lids and attached ring handles have fine angular planes that create a sleek, overall form. They are clearly a pair, with very little size difference and identical decoration. Each vessel rests on a high, square foot, the body swelling out in broad, flat planes and a straight, high neck. The exterior of the mouth is topped by a half-inch decorative band. A narrow lip protruding into the mouth surrounds the interior edge of both containers.

Two loop handles hang from masklike appliquéd animal-design plaques that at-tach at opposite sides of the vessel. The mask resembles a demon or stylized *taotie* design and is adorned with tightly spiral-ing *leiwen* or cloud-scroll patterns.[22] The "beak" or mouth of the demon holds the loose ring handle. The lid is square with an inch-long tongue that fits into the ves-sel. The lid exterior gently angles up and out from the edge, while the top is formed by four flat planes rising to a square, flat top. Four S-shaped spirals attach to the four edges of the lid, which is hollow. The patina on the pair is a mixture of bright, rich green and dull, muted gray-green. Traces of dirt cover the whole surface.

Large wine storage vessels of bronze, ceramic, and lacquer appear frequently in the Han period, in both the round and the popular *fang* or square forms. Wang Zhong-shu notes that ritual forms became trans-formed during the Han period into forms more "suitable to the need of real life."[23] This expansion of bronze manufacture beyond its previous ritual role meant that bronzes were certainly more widely dis-tributed than ever before. The two wine vessels shown here are similar to those found in the Han tomb at Mancheng.[24] The Sze Hong vessels have retained their lids and thus more closely resemble the lacquer and pottery *hu* from Changsha.[25] The appliquéd handle design is also preva-lent on pottery *hu* and other bronze square *hu* found in Hebei.[26] The simple, plain bronzes appear to be a product that became popular during the mid–Western Han period.[27] —J. M.W.

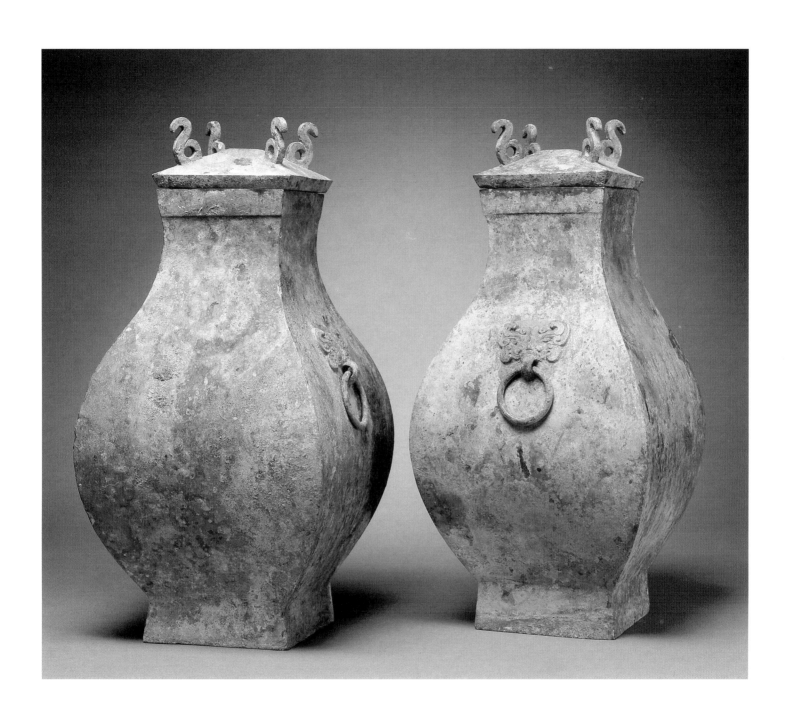

35. Jar

Stoneware, partially glazed
Han dynasty, 206 B.C.–A.D. 220
H: 12¼ in. D: 11 in.
351.1987

This tall storage jar of fine, hard stone-
ware with partial glaze across the top half
of the vessel rests on a trimmed foot ring.
The vessel was roughly constructed on
a wheel, and heavy trim marks rib the
lower exposed red-clay body. The body
is thick throughout except for the neck
and wide, flaring lip, where it thins. From
the rough interior the neck appears to
have been luted onto the body. Two loop
handles on opposite sides of the vessel are
luted onto the sharply sloping shoulder.

Divided into three main horizontal
bands that appear to be carved from
the body rather than appliquéd over the
vessel, this jar has a direct, natural look
that is enhanced by a thin layer of green
glaze covering its top half. The overall
impression of the decoration is one of
spontaneity and liveliness, from the free-
flowing inscribed motif on the two top
panels of the main body to the wavelike
pattern that adorns the neck and the exte-
rior of the lip. Appliquéd S-shaped de-
signs in heavy clay rest atop the handles,
which are also roughly engraved with a
geometric pattern.

Practical wares like this round-bodied
wine-storage jar were clearly treated dif-
ferently than wares made for the tomb.
In this fairly common type of jar, we see
the beginnings of a true glaze that adheres
well. The coarseness of construction as
well as the relative frequency of the design
indicates that this was a common form in
the Han period. The hard, dense stone-
ware body provided a good receptacle for
liquids, and the wide mouth was conven-
ient for pouring.

Archaeological evidence suggests that
this type of hard ware with green glaze
originated in the south of China; it has
been found in tombs around Hunan and
Jiangsu provinces.[28] It differs significantly
from the majority of lead-glazed tomb
wares (cat. no. 31) and is also quite dif-
ferent in body type and glaze from West-
ern Jin proto-*yue* wares (see cat. no. 36).

—J.M.W.

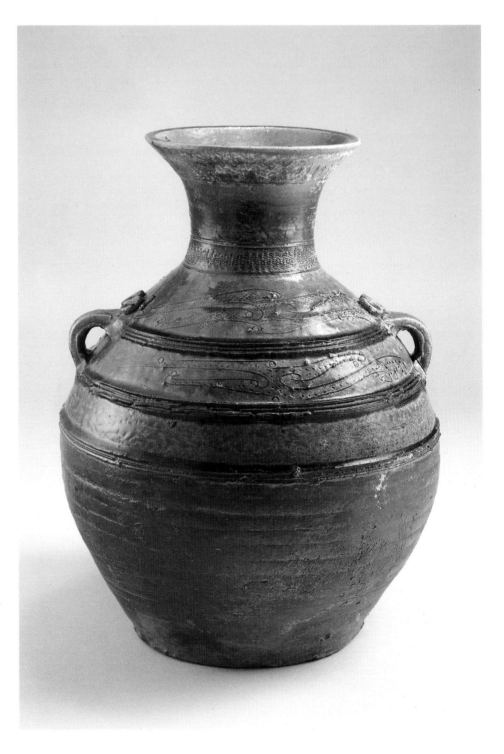

Notes

1. See Walter Hochstader, "Pottery and Stonewares of Shang, Chou and Han," *Bulletin of the Museum of Far Eastern Antiquities*, 1952, no. 24: "When the fire had died down upon completion of the baking process, alternate layers of wet straw and earth were placed on top of the kiln, over which small quantities of water were poured at intervals. Thus, the atmosphere of the kiln became saturated with moisture" (p. 83).

2. Shaoxing Cultural Relics CHE, "Zhejiang Shaoxing Fusheng zhanguo" (The site of Warring States kilns at Fusheng, Shaoxing, Zhejiang), *Kaogu*, 1979, no. 3, pp. 231–34. In discussing the "dragon" kiln found at Shaoxing, the authors refer to the presence of aluminum oxide, as found in Shang earthenware, which allowed for a decidedly higher firing temperature than the earlier Neolithic wares.

3. Hochstader, "Pottery and Stonewares," p. 100.

4. See Margaret Medley, *The Chinese Potter: A Practical History of Chinese Ceramics* (London: Phaidon Press, 1986), p. 28. In discussing Neolithic Longshan ware, Medley describes the necessity of either an imbibing process or a closing of the flue at the correct time to produce the black ware. The later black wares of Shang and Zhou required the same kind of reduction firing process to create the black body.

5. Hochstader, "Pottery and Stonewares," p. 94, ill. no. 84.

6. Ibid., p. 92.

7. Ibid., p. 94.

8. Yutaka Mino and Katherine R. Tsiang in *Ice and Green Clouds: Traditions of Chinese Celadon* (Indianapolis: Indianapolis Museum of Art, 1986) suggest that the traditional designations of North and South as centers of ceramic production are inadequate to describe the growth of regional ceramic centers. Their designation of a third center as east-central "centered around the lower Yangzi River valley and Hangzhou Bay, including the provinces of Jiangsu and Zhejiang, the southern part of Anhui, and the northern part of Jiangxi . . ." (p. 16) more precisely defines the regional differences found in these ceramics.

9. Ibid., pp. 44–45, pl. 9. Mino illustrates two excavated vessels from *Kaogu*; see p. 44, nos. 9a and 9b.

10. Henry Trubner, *Arts of the Han Dynasty* (New York: Asia Society, 1961), p. 33, no. 38, refers to a bronze vessel in a collection belonging to Cornelius Costello.

11. Ibid., p. 30, pl. 28. This vessel, from the Museum of Fine Arts, Boston, has no lid but is similar in shape as well as design motifs.

12. Suzanne G. Valenstein, *A Handbook of Chinese Ceramics*, rev. ed. (New York: Metropolitan Museum of Art, 1989), p. 43, "*canjian hu*," illustrated p. 44, pl. 38.

13. Wang Zhongshu, *Han Civilization* (New Haven: Yale University Press, 1982), p. 142, "*yadan hu*," illustrated pl. 187.

14. Ibid., p. 142.

15. Valenstein, *A Handbook of Chinese Ceramics*, p. 293, no. 38: "One of twelve cocoon-shaped, lidded flasks that came from a tomb cleared in 1973 in Tongshan xian, Jiangsu province is ill., *Wenwu ziliao congkan* 1 (1977), pp. 105–10 and fig. 6. The tomb has been attributed to the early part of the Western Han dynasty."

16. Shaanxi Provincial Cultural Administrative Committee and Dali District Cultural Bureau. "Chaoyi zhanguo muzang fajue jianbao" (Report of the excavation of Warring States tombs at Chaoyi), *Wenwu ziliao congkan*, 1978, no. 2, pp. 75–89 and p. 85, figs. 23 and 24. Dating is noted on p. 88.

17. See Li Zhiyan, "Han dai youtao de qiyuan he tedian" (The origin and special characteristics of Han dynasty glazed pottery), *Kaogu yu wenwu*, 1984, no. 1, pp. 91–95, for the origins of lead-glazed wares in China. Also see Wang, *Han Civilization*, p. 144.

18. A jar with nearly identical relief decoration, in the collection of Mr. and Mrs. Eugene Bernat, is illustrated in Trubner, *Arts of the Han Dynasty*, p. 28, no. 22.

19. See Bartold Laufer, *Chinese Pottery of the Han Dynasty* (Leiden: E.J. Brill, 1909; reprint, Rutland, Vt., and Tokyo: Charles E. Tuttle, 1962), p. 181.

20. See Wang, *Han Civilization*. The many fine bronze objects from Mancheng further attest to the craftsmanship of the time.

21. See the bronze phoenix lamp in the Royal Ontario Museum collection, illustrated in Ezekiel Schloss, *Art of the Han* (New York: China House, 1979), p. 37, pl. 33. See also the lamp in the shape of a kneeling ram excavated from Liu Sheng's tomb, Mancheng, Hopei.

22. The mask here is very similar to the kind found on other bronze *hu* from the Zhou and later periods. An excavated and much more elaborate square *hu* from Zhongshan is illustrated in Li Xueqin, *Eastern Zhou and Qin Civilizations*, trans. K. C. Chang (New Haven and London: Yale University Press, 1985), p. 99, indicating that this handle type was used early on in bronze production.

23. Wang, *Han Civilization*, p. 101. Wang goes on to describe the evolution of bronze manufacture and the use of bronzes in the Han period. His comments regarding Han dynasty excavated objects have proven very useful.

24. Ibid., ill. no. 124; although the Mancheng vessel has an important inscription, the shape is essentially the same as that of the Sze Hong pieces.

25. See Hunan Provincial Museum, "Hunan Changsha Huangtuling Weijia da dui Zhanguo mu" (The Warring States tomb mounds of Weijia in the Huang mountain range, Changsha, Hunan), *Wenwu ziliao congkan*, 1980, no. 3, pp. 113–17, for ceramic and pottery examples of same shape found at Changsha, Hunan province.

26. Ibid., pp. 1–25.

27. Wang, *Han Civilization*, p. 103.

28. Ibid., p. 145.

Six Dynasties, Tang, and Liao Dynasties

36. Jar

Stoneware with greenish glaze
Six dynasties, Western Jin dynasty, late
3rd century
H: 7½ in. D: 11¼ in.
94.1990

This wide-mouthed, wheel-thrown jar of fine, dense, gray stoneware is covered across the top portion with a thin green glaze. The base of the jar has no foot but is sharply concave on a plain, unglazed base. The vessel spreads in diameter gradually into a full, rounded body with a high shoulder and straight short neck that has been trimmed flat across the top. Two small loop handles appear at the shoulder. The vessel very likely had a lid, which is now lost.

The vessel is decorated in both stamped and appliquéd designs around the shoulder. A pair of horizontal bands, perhaps etched or carved into the top of the design, are followed by three separate horizontal bands of stamped design: the topmost is a band of horizontal circles, the middle a diamond/lozenge pattern, and below it a double band of stamped circle design. On opposing sides of the vessel are the two loop handles, crudely fashioned of thick clay with a stamped or etched design decorating the exterior. On the opposite two sides are appliquéd designs of goats complete with horns and beards. The vessel is covered overall with a grayish green glaze that adheres well to the shoulder of the vessel but shows signs of thin-

ning and deterioration on the lower part.

Often referred to as proto-*yue*, this type of hard, glazed stoneware was most often wheel-thrown, with the appliquéd design applied in the leather-hard stage. The term "proto-*yue*" is used to distinguish the early stages of this type of ware from the more accomplished post-Tang *yue* ware.[1] This type of bowl is one of the most popular of the early proto-*yue* shapes. Proto-*yue* ceramics have been found in tombs dating to the Western Jin period, and they frequently exhibit methods of decoration and glazing similar to those found on the Sze Hong bowl.[2]

—J.M.W.

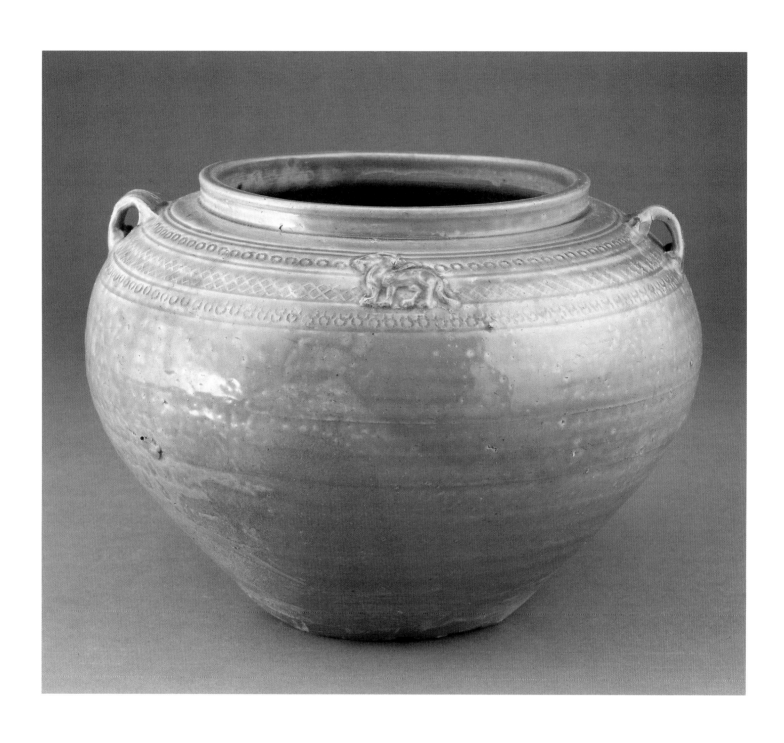

37. Chicken-spouted ewer

Stoneware with green glaze
Six Dynasties, Eastern Jin dynasty,
4th century
H: 9 1/2 in. D: 9 in.
490.1987

This ewer has a globular body, chicken-head spout, slender neck, and flaring lip that rises into a vertical rim. A tapered handle arcs from its rim to its shoulder, where a double line encircles the vessel. Two horizontal, square-cut lugs are attached over these incised lines; they are centered on either side of the ewer laterally between its spout and handle. The stoneware vessel is covered with a greenish glaze that extends over its rounded body, stopping at its concave foot.

Ewers with a spout in the form of a chicken's head (*tianjihu*) originated during the Eastern Jin period (317–420). Numerous examples from southern China survive, including one discovered in a tomb near Nanjing dated 358 and another excavated from a tomb at Changsha dated 375.[3] It is doubtful that this ewer ever held or poured liquids. Its spout has only a small, constricted pouring channel, and its concave foot is thinly potted with an open fissure. Vessels with functional chicken-head spouts apparently derive from those with a solid chicken's head and tail simply attached at the shoulder.[4] Later chicken-spouted ewers tend to have a tall, elongated form, rather than the short, round bodies of those from the second half of the fourth century.[5] Jars with nonfunctioning spouts presumably were meant for burial, but the reasons for having a chicken-head attachment on a vessel remain unknown. Although uncommon, a ram-headed variation of the motif appears on a jar excavated at Mufushan, Nanjing.[6] —R.Y.O.

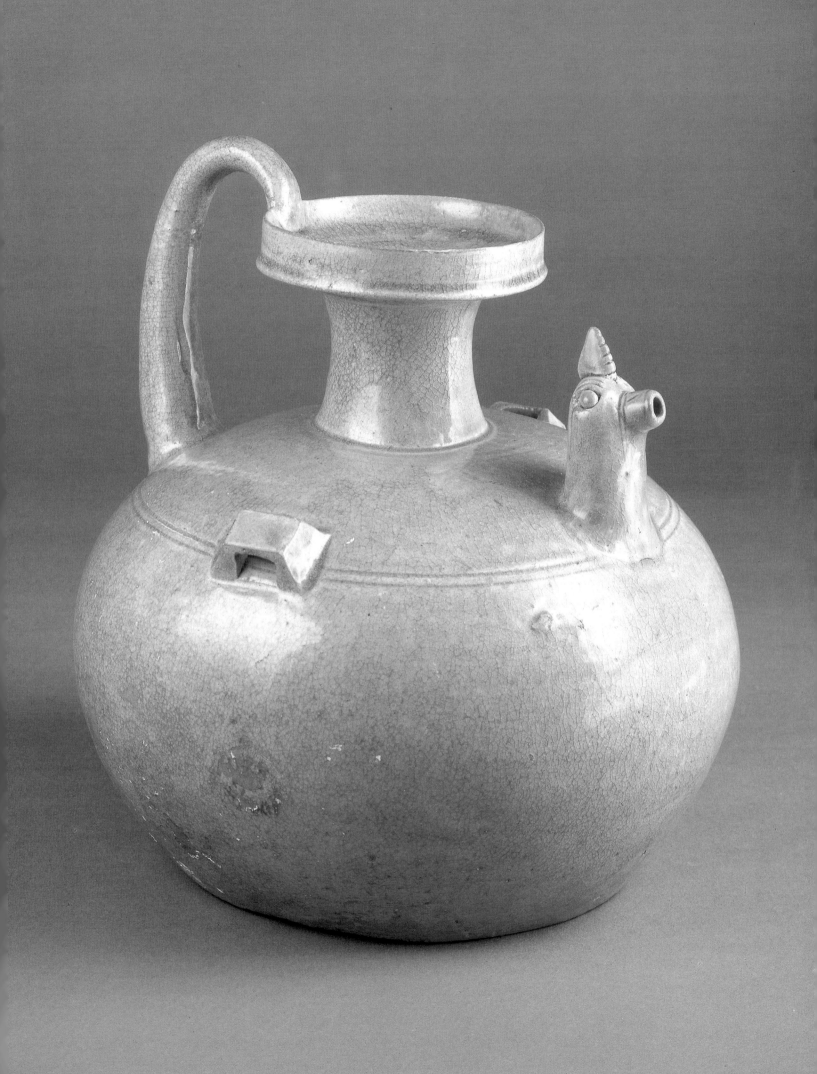

38. Tripod jar

Earthenware with three-color glaze
Tang dynasty, 8th century
H: 5 1/2 in. D: 8 1/2 in.
470.1987

Tripod vessels of ceramic and metal have a long history in China. Their continued popularity into the Tang period is represented by vessels like this *fu*. Three legs in the form of animal feet support its body just off the ground. Two wheel-turned lines encircle the tripod's mid-section, defining its waist, and a rounded lip rises from its shoulder, opening into a wide mouth.

Many vessels of this type have relief motifs decorating their sides and shoulders, but this *fu* is plain.[7] Its simple form is suited to the rich patterns created by the multicolored lead glazes decorating it. Its lip is yellow-brown, a color that also trails over its lower body and upper legs. A deep blue covers its shoulder and trickles down its sides; it is offset by areas left in reserve to reveal a white slip undercoating beneath a clear glaze. Resisting the blue glaze, fourteen circular areas around its shoulder are dabbed with touches of the yellow-brown glaze.

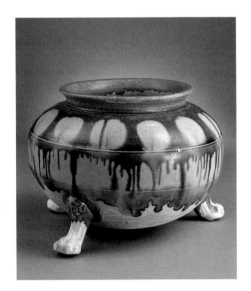

38a. **Tripod jar**
Earthenware with three-color glaze
Tang dynasty, 8th century
H: 6 1/2 in. D: 8 3/4 in.
563.1987

The use of gum or wax to protect certain glazed areas before covering proximate areas with glaze of a different color is related to dyeing techniques used in textiles. Fabrics colored in this manner were known in Tang China, most likely introduced from central Asia, and Tang tomb figures depict persons wearing garments made with resist-dyed cloth.[8]

The distinctive blue-glaze pattern on this tripod is executed in green on a related vessel (fig. 38a). These *fu* most likely came from the Xiaohuangye cun and Dahuangye cun kilns at Gong xian in Henan, where a tripod jar with similar decoration was discovered.[9] Relatively few kilns are known that produced Tang lead-glazed ceramics. Recent discoveries made at the Yaozhou kilns, Huangbaozhen, in Tongchuan, Shaanxi province, have revealed ceramics much like those from Gong xian.[10] —R.Y.O.

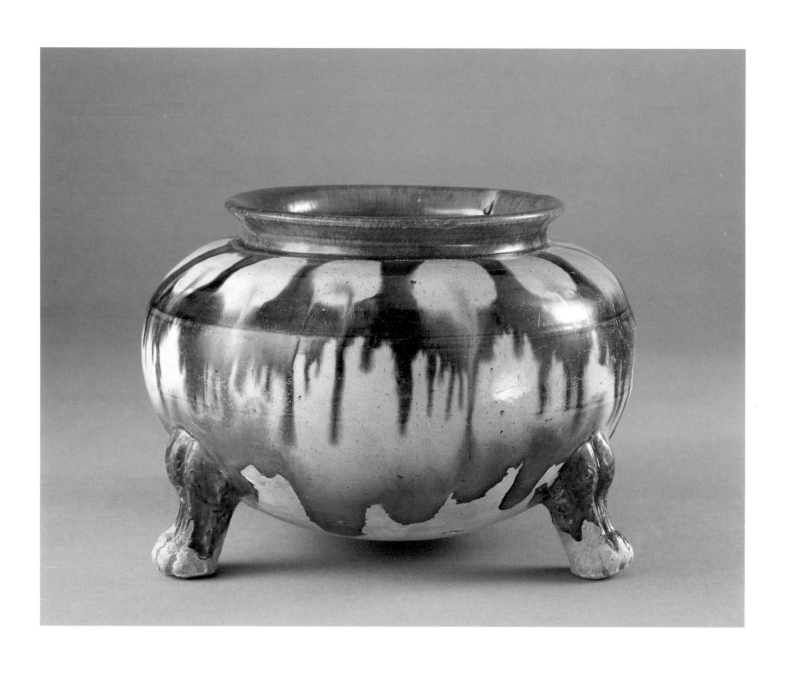

39. Jar

Porcelaneous ware with clear glaze
Tang dynasty, 8th–9th century
H: 6 1/2 in. D: 10 1/8 in.
564.1987

With neither neck nor foot, this jar's form is defined by its rounded body. Its sides curve into a gentle shoulder that slopes inward to a wide mouth edged with a rim, indicating that the jar may once have had a lid. A clear glaze covers the upper two-thirds of this vessel, leaving its lower body bare, where a wheel-turned line is visible. Frequently white slip is applied over the clay body of a vessel to enhance the clarity of its glaze.[11] The whiteness of this jar, however, is the result of the clay's color.

Tang white wares exhibit considerable differences, ranging from plain forms to elaborate shapes and decorations. Certain shapes are inspired by Persian metalwork, while others continue the traditional forms of Chinese *yue*-ware ceramics. As white porcelaneous wares increased in popularity, there was a steady decline in the production of green-glazed ceramics. Excavations of Sui and Tang dynasty kilns indicate that this transition occurred from the late seventh to the ninth century.[12]

Fragments of Chinese white wares found at Samarra and Nishapur, sites in Iraq and Iran dating to the ninth and tenth centuries, indicate the export of this material westward. Archaeological evidence also shows that Tang white porcelaneous wares reached Southeast Asia, Korea, and Japan in great numbers.[13] —R.Y.O.

40. Ewer with lion handle

Porcelaneous ware with clear glaze
Tang dynasty, 8th–9th century
H: 4 5/16 in. D: 2 5/16 in.
III.1989

This small ewer has an ovoid body with
a short spout set high on its shoulder. Its
cylindrical neck rises to a rounded lip that
attaches to a curved handle opposite the
spout. The handle is in the form of a lion
with its hind legs on the vessel's shoulder,
its forelegs over the rim, and its head ex-
tended within the neck as if attempting to
drink. The white clay body is covered
with a clear, slightly bluish glaze that
extends to the bevel of the flat foot. A
similar ewer with wider mouth and fuller
body is in the Ashmolean Museum's
collection.[14] —R.Y.O.

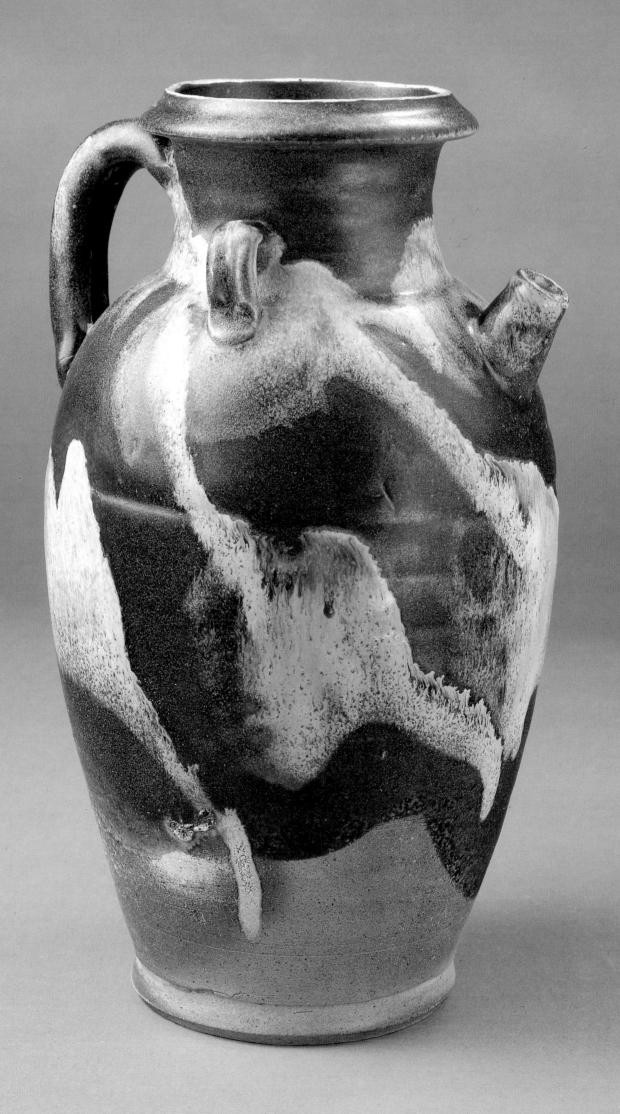

41. Ewer

Stoneware with suffused glaze
Tang dynasty, 9th century
H: 11 7/16 in. D: 6 5/16 in.
567.1987

Covered in a dark brown glaze suffused
with splashes of blue-white, this tall ewer
is enlivened by the bold contrast of its
colors. The glaze patterns accentuate
the ewer's body by flowing over its ovoid
form in a seemingly free manner. Stand-
ing on a flat, unglazed foot, the ewer has
rounded shoulders affixed with a short
spout and a double-coil handle rising to
the lip of its high neck. Two double-coil
loops appear at the base of the neck, set
laterally from the spout and handle. The
brown glaze stops well above the ewer's
foot and was wiped away from its rim,
presumably to apply the light-color glaze
and fire the vessel while it stood on its
mouth.

A large jar with four lug handles (fig.
41a) also has an unglazed rim. There is
evidence that at least some of the splashed
glazes were applied while the jar was
upside-down. This appears to have been
the case with a jar with an unglazed
mouth in the Newark Museum's collec-
tion, which has suffused glazes seeming
to gravitate toward its top; it was appar-
ently fired, however, while standing on its
foot.[15] With an unglazed rim, a vessel
could also be fired with a lid or cover in
place, allowing for the even warping and
shrinking of both pieces.[16]

Suffused glazes of contrasting colors
appear on a variety of vessel shapes. As
a rule, they are utilitarian forms with
handles and lugs attached and, less fre-
quently, relief decoration.[17] Sometimes
the color relationship is reversed, and the
light-colored glaze has splashes of dark
suffusions. Tang dynasty kilns that pro-
duced suffused-glazed wares are known
from several excavated sites in Henan
province and from a recent find in
Shaanxi.[18] —R.Y.O.

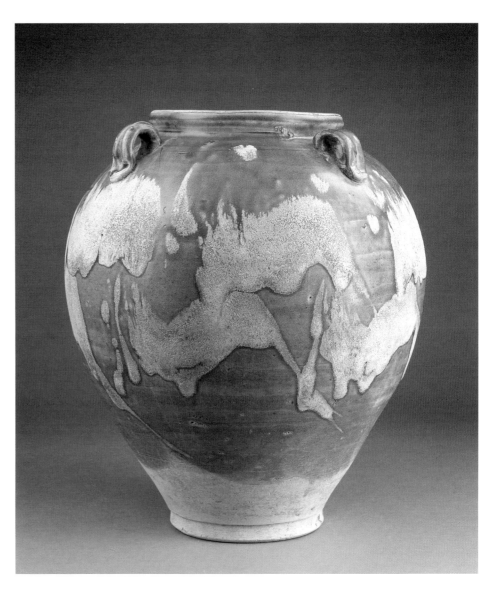

41a. **Jar with four lug handles**
Stoneware with suffused glaze
Tang dynasty, 9th century
H: 14 5/8 in. D: 14 in.
558.1987

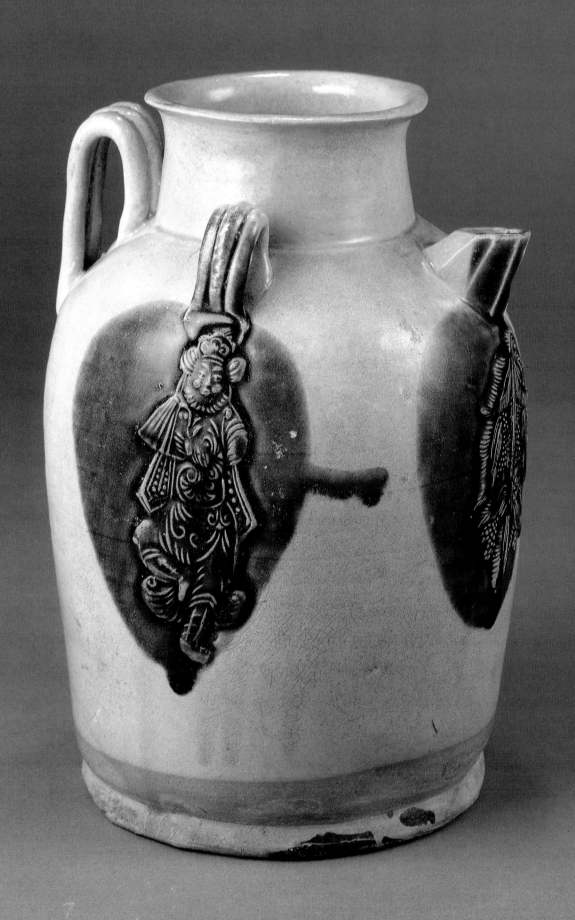

42. Ewer

Changsha ware, glazed stoneware
Tang dynasty, 9th century
H: 9 in. D: 6 5/8 in.
346.1987

With a full body and upright sides, this stout ewer has medallions with low-relief motifs beneath its spout and lugs. The medallion under the blunt, faceted spout depicts a cluster of feathery leaves and fruit, possibly from a date palm, with a perched bird; those under its two triple-coil lugs portray a bearded performer dancing to the accompaniment of his own whistling and music playing. A triple-coil handle loops from the ewer's shoulder to the base of its wide neck, which flares to an everted rim. Covered first with a white slip, the ewer has a yellow glaze running down to its beveled foot; its three molded decorations are further enhanced with splashes of brown glaze.

Ceramics from the Changsha area of Hunan province characteristically have bodies made of low-grade clay, a condition that is offset by inventive designs and decoration.[19] In addition to low-relief motifs, they are painted with lively images of birds, plants, animals, and geometric patterns, or inscribed with lines of calligraphy in various combinations of blue, green, and brown.[20]

One of the excavated Changsha kiln sites is at Tongguanzhen, where vessels with applied molded decorations were manufactured, many depicting exotic themes from western Asia. Changsha-ware ewers, in fact, have been recovered from southeast to western Asia. Their wide distribution suggests that many of the Changsha ceramics were actively exported.[21] —R.Y.O.

43a. **Plate**
Stoneware with lead glaze
Liao dynasty, 907–1125
H: 2 ¼ in. D: 10 in.
158.1989

43. Plate

Stoneware with lead glaze
Liao dynasty, 907–1125
H: 2 1/4 in. D: 9 1/4 in.
159.1989

This deep plate rests on a trimmed foot ring and has a stamped, floral-design interior with a plain, white-slipped and clear-glazed ground. Alternating green and straw-colored glazes highlight the interior's stamped design. The central medallion consists of an impressed wheel shape decorated with a straw-color glaze that radiates out into a green glaze. The lip is slightly inverted, with a horizontal band across the upper quarter-inch. The ground of the exterior has also been treated with a white slip. The glaze both inside and out is light and uneven.

The exterior of the plate is covered with a rich, straw-colored glaze with crackling and some iridescent areas. The interior of the foot ring is covered by a thin, uneven, spotted greenish glaze. The foot has been trimmed and left unglazed. Three spur marks show in the bottom interior of the plate.

Another example of the same plate type from the Sze Hong collection (fig. 43a) shows alternating colors of green and a gold-toned yellow, which mark the leaves and flowers of the sharply stamped interior design in a highly naturalistic fashion. The pinkish clay body is covered with a flat white slip that provides a white ground for the brilliant colors. The foot is completely unglazed; the green glaze of the plate's exterior stops several inches from the foot ring. Three spur marks are clearly evident in the interior of this plate.

The rim treatment is the same as that of cat. no. 43, but the overall profile is slightly flatter and wider, with a more gradual slope to the sides.

These two plates are typical of later Liao ceramics in their shape, decoration, and body type. The three-color ware, commonly associated with Tang dynasty *mingqi*, actually has little direct relationship to the Tang ceramics, other than the use of lead glazes.[22] Perhaps due to the influence of Chinese potters to the south, Liao ware demonstrates a fine, dense body that is imperfect but extremely exuberant in execution. Liao wares of a very similar shape and decoration to the Sze Hong pieces can be seen in the Liaoning Provincial Museum collection.[23] —J.M.W.

Notes

1. Margaret Medley, *The Chinese Potter: A Practical History of Chinese Ceramics* (London: Phaidon Press, 1986), p. 60.

2. J. M. Addis, *Chinese Ceramics from Datable Tombs and Some Other Dated Material: A Handbook* (London and New York: Sotheby Parke Bernet, 1978), p. 7, no. 4.

3. Annette L. Juliano, *Art of the Six Dynasties: Centuries of Change and Innovation* (New York: China Institute in America, 1975), p. 30.

4. Valrae Reynolds et al., "2000 Years of Chinese Ceramics: The Newark Museum Collection," *The Newark Museum Quarterly* 28, nos. 3–4 (Summer/Fall 1977), p. 12.

5. Jan Fontein and Tung Wu , *Unearthing China's Past* (Boston: Museum of Fine Arts, 1973), pp. 137–40.

6. Terukazu Akiyama et al., *Arts of China: Neolithic Cultures to the T'ang Dynasty, Recent Discoveries* (Tokyo and Palo Alto: Kodansha International, Ltd., 1968), pp. 90, 219 and fig. 156.

7. See William Watson, *Tang and Liao Ceramics* (New York: Rizzoli International Publications, Inc., 1984), figs. 30, 122.

8. Ibid., p. 57.

9. Fu Yongkui, "Henan Gong xian Da, Xiaohuangye cun Tang sancai yaozhi di tiaocha jianbao" (A report of the investigations of sancai kiln remains at Dahuangye and Xiaohuangye villages in Gong xian, Henan), *Kaogu yu wenwu*, 1984, no. 1, pp. 69–70, fig. 2.

10. Suzanne G. Valenstein, *A Handbook of Chinese Ceramics*, rev. ed. (New York: Metropolitan Museum of Art, 1989).

11. Ibid., p. 72.

12. Masahiko Satō, *Chinese Ceramics: A Short History*, trans. of *Chūgoku tōjishi* (History of Chinese ceramics), 1978, by Kiyoko Hanaoka and Susan Barberi (New York and Tokyo: Weatherhill/Heibonsha, 1981), pp. 51–52.

13. Valenstein, *Handbook*, p. 72; and Satō, *Chinese Ceramics*, p. 81.

14. Margaret Medley, *T'ang Pottery and Porcelain* (London: Faber and Faber Ltd., 1981), p. 82, fig. 81.

15. See ibid., color pl. L, or Reynolds, "2000 Years," cover.

16. This opinion was expressed by Robert D. Mowry in conversation, 1992.

17. See Watson, *Tang and Liao Ceramics*, fig. 44.

18. Valenstein, *Handbook*, p. 74.

19. Ibid., p. 75.

20. See Timothy See-Yiu Lam, *Tang Ceramics: Changsha Kilns* (Hong Kong: Lammett Arts, 1990), pls. 145–70 (nos. 243–68).

21. Satō, *Chinese Ceramics*, p. 88.

22. Watson, *Tang and Liao Ceramics*, p. 236, raises doubts as to any direct "craft continuity" between the Liao and the Tang *sancai* wares. Namio Egami, *Dai sansai: Tōsansai, Ryosansai, Perushasancai, Narasansai* (Tang, Liao, Persia and Nara period three-color ware) (Tokyo: Han'a Sai'a Bunka Kōryū Sentaa and Daiichi Kikaku Kabushiki Kaisha, 1989), p. 11, states that "Liao three-color ware has little in common with that of Tang. The shapes, patterns of decorations, and glazes all differ."

23. Illustrated in Egami, *Dai sansai*, published in conjunction with the Loyang Museum and the Liaoning Provincial Museum, p. 100, cat. nos. 81 and 82.

Selected Bibliography

Addis, J. M. *Chinese Ceramics from Datable Tombs and Some Other Dated Material: A Handbook.* London and New York: Sotheby Parke Bernet, 1978.

Akiyama, Terukazu, et al. *Arts of China: Neolithic Cultures to the T'ang Dynasty, Recent Discoveries.* Tokyo and Palo Alto: Kodansha International, 1968.

Allen, Maude Rex. "Early Chinese Lamps." *Oriental Art* 2, no. 4 (Spring 1950), pp. 133–40.

Andersson, J. Gunnar. *Children of the Yellow Earth.* London: Kegan Paul, Trench, and Trubner, 1934.

———. *Preliminary Report on Archaeological Research in Kansu.* Geological Survey of China, ser. A:5. Beijing, 1925.

———. "Researches into the Prehistory of the Chinese." *Bulletin of the Museum of Far Eastern Antiquities* 15 (1943).

Archaeological Team, CPAM of Qinghai Province and the Institute of Archaeology, CASS. *Qinghai Liuwan.* 2 vols. Beijing: Wenwu Press, 1984.

Bagley, Robert W. "The Beginnings of the Bronze Age: The Erlitou Culture Period." In *The Great Bronze Age of China,* ed. Wen Fong, pp. 67–77. New York: Metropolitan Museum of Art, 1980.

———. "Shang Ritual Bronzes: Casting Technique and Vessel Design." *Archives of Asian Art* 43 (1990), pp. 6–20.

———. *Shang Ritual Bronzes in the Arthur M. Sackler Collection.* Vol. 1 of *Ancient Chinese Bronzes in the Arthur M. Sackler Collections.* Washington, D.C., and Cambridge, Mass.: Arthur M. Sackler Foundation and Arthur M. Sackler Museum, Harvard University, 1987.

Barnard, Noel. *The First Radiocarbon Dates from China.* Monographs on Far Eastern History, no. 8. Canberra: Department of Far Eastern History, Research School of Pacific Studies, Institute of Advanced Studies, Australian National University, 1972.

———. "Wrought Metal-working Prior to Middle Shang—A Problem in Archaeological and Art-historical Research Approaches." *Early China,* 1980–81, no. 6, pp. 4–30.

Bodde, Derk. *Festivals in Classical China: New Year and Other Annual Observances during the Han Dynasty 206 B.C.–A.D. 220.* Princeton: Princeton University Press, 1975.

———. "Myths of Ancient China." In *Mythologies of the Ancient World,* ed. Samuel N. Kramer, pp. 367–408. New York: Doubleday, 1961.

Boltz, William G. "Early Chinese Writing." *World Archaeology* 17, no. 3 (Feb. 1986), pp. 420–36.

Capon, Edmund, and Werner Forman. *Tang China: Vision and Splendour of a Golden Age.* London: Macdonald and Co., 1989.

Chang, Kwang-chih. "The Animal in Shang and Chou Bronze Art." *Harvard Journal of Asiatic Studies* 41 (1981), pp. 527–54.

———. *The Archaeology of Ancient China.* 4th ed. New Haven: Yale University Press, 1986.

———. *Art, Myth, and Ritual: The Path to Political Authority in Ancient China.* Cambridge, Mass.: Harvard University Press, 1983.

———. *Early Chinese Civilization: Anthropological Perspectives.* Harvard-Yenching Institute Monograph Series, vol. 23. Cambridge, Mass.: Harvard University Press, 1976.

———. *Shang Civilization.* New Haven: Yale University Press, 1980.

———. *Studies in Chinese Archaeology.* Hong Kong: Chinese University Press, 1982.

———, ed. *Food in Chinese Culture: Anthropological and Historical Perspectives.* New Haven: Yale University Press, 1977.

———, ed. *Studies of Shang Archaeology: Selected Papers from the International Conference on Shang Civilization.* New Haven: Yale University Press, 1986.

Chase, W. Thomas. *Ancient Chinese Bronze Art: Casting the Precious Sacral Vessel.* New York: China Institute in America, 1991.

Chen Fang-mei. "The Stylistic Development of Shang and Zhou Bronze Bells." Trans. Rob Linrothe. In *Style in the East Asian Tradition,* ed. R. Scott and G. Hutt, pp. 19–37. Colloquies on Art and Archaeology in Asia, no. 14. London: Percival David Foundation of Chinese Art, 1987.

Cheng Changxin, Qu Delong, and Jiang Dong-fang. "Beijing jianxuan yizu ershibajian Shang daidai mingtong qi" (Twenty-eight inscribed Shang dynasty bronzes from Beijing). *Wenwu,* 1982, no. 9, pp. 34–43.

Cheng Te-k'un. *Chou China.* Vol. 3 of *Archaeology in China.* Cambridge: W. Heffer and Sons, 1963.

———. *Prehistoric China.* Rev. ed. Vol. 1 of *Archaeology in China.* Cambridge: W. Heffer and Sons, 1966.

Cheng Wei. *Zhongguo caitao yishu* (The art of Chinese painted pottery). Shanghai: Shanghai Renmin Press, 1985.

Cheung Kwong-yue. "Recent Archaeological Evidence Relating to the Origin of Chinese Characters." In *The Origins of Chinese Civilization,* ed. David N. Keightley, pp. 323–91. Berkeley: University of California Press, 1980.

Dien, Albert E., Jeffrey K. Riegel, and Nancy T. Price, eds. *Chinese Archaeological Abstracts, 2–4.* Monumenta Archaeologica, nos. 9–11. Los Angeles: Institute of Archaeology, University of California, 1985.

Egami, Namio, ed. *Dai sansai: Tosansai, Ryosansai, Perushasansai, Narasansai* (Tang, Liao, Persia, and Nara period three-color ware). Tokyo: Han'a Sai'a Bunka Kōryū Sentaa and Daiichi Kikaku Kabushiki Kaisha, 1989.

Fong, Wen, ed. *The Great Bronze Age of China: An Exhibition from the People's Republic of China.* New York: Metropolitan Museum of Art and Alfred A. Knopf, 1980.

Fontein, Jan, and Tung Wu. *Han and T'ang Murals.* Boston: Museum of Fine Arts, 1976.

———. *Unearthing China's Past.* Boston: Museum of Fine Arts, 1973.

Fu Yongkui. "Henan Gong xian Da, Xiaohuang-ye cun Tang sancai yaozhi di tiaocha jianbao" (A report of the investigations of sancai kiln remains at Dahuangye and Xiaohuangye villages in Gong xian, Henan). *Kaogu yu wenwu,* 1984, no. 1, pp. 69–81.

Gansu Provincial Museum and the Gansu Provincial Cultural Relics Team, eds. *Gansu caitao* (Gansu painted pottery). Beijing: Wenwu Press, 1984.

Hartman, Joan M. "Chinese Ceramic Sculpture in the Collection of Mr. and Mrs. Ezekiel Schloss." *Oriental Art,* n.s. 15, no. 4 (Winter 1969), pp. 286–95.

Hayashi Minao. *In Shū jidai seidōki no kenkyū* (Study of Yin and Zhou bronzes). *In Shū jidai seidōki soran ichi/ni* (Conspectus of Yin and Zhou bronzes I–II). 3 vols. Tokyo: Yoshikawa Kōbunkan, 1984.

———. "In Shū seidōki meimon chūzō hō ni kansuru jakkan no mondai" (Notes on the method of casting inscriptions on Yin and Zhou bronzes). *Tōhō Gakuhō* 51 (March 1979), pp. 1–58.

Hentze, C. *Chinese Tomb Figures.* London: Edward Goldston, 1928.

Ho Ping-ti. *The Cradle of the East: An Inquiry into the Indigenous Origins of Techniques and Ideas of Neolithic and Early Neolithic Historic China, 5000–1000 B.C.* Hong Kong: Chinese University of Hong Kong Press, 1975.

Hochstader, Walter. "Pottery and Stonewares of Shang, Chou and Han." *Bulletin of the Museum of Far Eastern Antiquities* 24 (1952), pp. 81–108.

Hsu Cho-yun. *Ancient China in Transition: An Analysis of Social Mobility, 722–222 B.C.* Stanford Studies in the Civilizations of Eastern Asia. Stanford: Stanford University Press, 1965.

Hsu Cho-yun and Katheryn M. Linduff. *Western Chou Civilization.* New Haven: Yale University Press, 1988.

Huber, Louisa G. Fitzgerald. "The Traditions of Chinese Neolithic Pottery." *Bulletin of the Museum of Far Eastern Antiquities* 53 (1981), pp. 1–253.

Hughes-Stanton, Penelope, and Rose Kerr, comps. *Kiln Sites of Ancient China: An Exhibition Lent by the People's Republic of China.* London and Oxford: Oriental Ceramic Society, 1980.

Institute of Archaeology of the Chinese Academy of Science. *Huixian fajue baogao* (Report on the excavation at Huixian). Beijing: Kesue Press, 1956.

James, Jean H. "Interpreting Han Funerary Art: The Importance of Context." *Oriental Art* 31, no. 3 (Autumn 1985), pp. 283–92.

Juliano, Annette L. *Art of the Six Dynasties: Centuries of Change and Innovation.* New York: China Institute in America, 1975.

———. *Bronze, Clay and Stone: Chinese Art in the C. C. Wang Family Collection.* Seattle: University of Washington Press, 1988.

Karlgren, Bernhard. *A Catalogue of Bronzes in the Alfred F. Pillsbury Collection.* Minneapolis: Minneapolis Institute of Arts, 1952.

Keightley, David N. "Dead But Not Gone. . . ." Paper prepared for the conference "Ritual and the Social Significance of Death in Chinese Society." Oracle, Ariz., Jan. 1985.

———. "The Religious Commitment: Shang Theology and the Genesis of Chinese Political Culture." History of Religions 17, no. 3–4 (1978), pp. 211–25.

———. Sources of Shang History. Berkeley: University of California Press, 1978.

———, ed. The Origins of Chinese Civilization. Berkeley: University of California Press, 1983.

Kidder, J. Edward, Jr. Early Chinese Bronzes in the City Art Museum of St. Louis. St. Louis: City Art Museum, 1956.

Kingery, W. David, ed. Ceramics and Civilization. Vol. 1 of Ancient Technology to Modern Science. Columbus, Ohio: American Ceramic Society, 1985.

Kingery, W. David, and Pamela B. Vandiver. Ceramic Masterpieces: Art, Structure and Technology. New York: The Free Press, 1986.

Lam, Timothy See-Yiu. Tang Ceramics: Changsha Kilns. Hong Kong: Lammett Arts, 1990.

Laufer, Bertold. Chinese Pottery of the Han Dynasty. Leiden: E. J. Brill, 1909; reprint, Rutland, Vt., and Tokyo: Charles E. Tuttle, 1962.

Lawton, Thomas. Chinese Art of the Warring States Period: Change and Continuity, 480–222 B.C. Washington, D.C.: Freer Gallery of Art, Smithsonian Institution, 1982.

Lawton, Thomas, et al. Asian Art in the Arthur M. Sackler Gallery: The Inaugural Gift. Washington, D.C.: Arthur M. Sackler Gallery, Smithsonian Institution, 1987.

Leidy, Denise Patry. "Tufted Zoomorphs: Figural Images in Machang Ceramics." Journal of the Museum of Fine Arts, Boston 1 (1989), pp. 23–30.

Lewis, Candace J. Into the Afterlife: Han and Six Dynasties Chinese Tomb Sculpture from the Schloss Collection. Poughkeepsie, N.Y.: Vassar College Art Gallery, 1990.

———. "Tall Towers of the Han." Orientations 21, no. 8 (Aug. 1990), pp. 45–54.

Li Chi and Wan Chia-pao. Studies of the Bronze Ku-Beaker. Archaeologia Sinica, n.s., no. 1. Nankang, Taiwan: Academia Sinica, 1964.

Li Hui-liu. "The Domestication of Plants in China: Ecogeographical Considerations." In The Origins of Chinese Civilization, ed. David N. Keightley, pp. 21–63. Berkeley: University of California Press, 1983.

Li Xueqin. Eastern Zhou and Qin Civilizations. Trans. K. C. Chang. New Haven: Yale University Press, 1985.

———, ed. Qingtongqi (Bronzes). Pts. 1–2 of Gongyi meishu bian (Crafts section). Vols. 4–5 of Zhongguo meishu quanji (Complete collection of Chinese art). Beijing: Wenwu Press, 1985–86.

Lim, Lucy, ed. Stories from China's Past: Han Dynasty Pictorial Tomb Reliefs and Archaeological Objects from Sichuan Province, People's Republic of China. San Francisco: Chinese Culture Foundation of San Francisco, 1987.

Link, Howard A. "Curator's Choice: Robust Bronzes of the Honolulu Academy of Art." Orientations 5, no. 11 (Nov. 1974), pp. 29–40.

Loehr, Max. Relics of Ancient China from the Collection of Dr. Paul Singer. New York: Asia Society, 1965.

———. "Review of Archaeology in China. Vol. 1: Prehistoric China." Ars Orientalis 5 (1963), pp. 298–303.

———. "The Stratigraphy of Hsiao-t'un (Anyang) with a Chapter on Hsio-t'un Foundation Burials and Yin Religious Customs." Ars Orientalis 2 (1957), pp. 439–57.

Loewe, Michael. Everyday Life in Early Imperial China. New York: Dorset Press, 1968.

———. Ways to Paradise: The Chinese Quest for Immortality. London: Allen and Unwin, 1979.

Los Angeles County Museum of Art. The Quest for Eternity: Chinese Ceramic Sculptures from the People's Republic of China. San Francisco: Chronicle Books, 1987.

Medley, Margaret. The Chinese Potter: A Practical History of Chinese Ceramics. London: Phaidon Press, 1986.

———. T'ang Pottery and Porcelain. London: Faber and Faber, 1981.

Mino, Yutaka, and Katherine R. Tsiang. Ice and Green Clouds: Traditions of Chinese Celadon. Indianapolis: Indianapolis Museum of Art, 1986.

National Museum of History Editing Committee. Pottery Figurine: Eternal World of Ceramic Sculpture. Taipei: China Art Printing Works, 1988.

Palmgren, Nils. Kansu Mortuary Urns of the Pan Shan and Ma Chang Groups. Palaeontologia Sinica, ser. D, vol. 3, facs. 1. Beijing: Geological Survey of China, 1934.

Peking Museum of Chinese History. 7000 Years of Chinese Civilization: Chinese Art and Archaeology from the Neolithic Period to the Han Dynasty. Exh. cat. Milan, 1983.

Pope, John Alexander, Rutherford John Gettens, James Cahill, and Noel Barnard. The Freer Chinese Bronzes. Vol. 1. Freer Gallery of Art Oriental Studies, no. 7. Washington, D.C.: Smithsonian Institution, 1967.

Qinghai caitao (Qinghai painted pottery). Beijing: Wenwu Press, 1980.

Rao Zhongyi. "The Issue of the Origin of Writing Brought about by the Silk Road." Trans. Wu Ranyin. Originally published in Chinese in Ming Pao Monthly (Hong Kong) 25, no. 9 (Sept. 1990).

Rawson, Jessica. Chinese Bronzes: Art and Ritual. London: Trustees of the British Museum and Sainsbury Centre for Visual Arts, University of East Anglia, 1987.

———. Western Zhou Ritual Bronzes in the Arthur M. Sackler Collections. Vols. 2A–B of Ancient Chinese Bronzes in the Arthur M. Sackler Collections. Washington, D.C., and Cambridge, Mass.: Arthur M. Sackler Foundation and Arthur M. Sackler Museum, Harvard University, 1990.

Rawson, Jessica, and Emma Bunker. Ancient Chinese and Ordos Bronzes. Hong Kong: Oriental Ceramic Society of Hong Kong and the Urban Council of Hong Kong, 1990.

Reynolds, Valrae, et al. "2000 Years of Chinese Ceramics: The Newark Museum Collection." The Newark Museum Quarterly 28, no. 3–4 (Summer/Fall 1977).

Rosemont, Jr., Henry, ed. Explorations in Early Chinese Cosmology. Journal of the American Academy of Religion Thematic Studies, 50/2. Chico, Calif.: Scholars Press, 1984.

Royal Ontario Museum. Chinese Art in the Royal Ontario Museum. Toronto, 1972.

Rudolf, Richard C., ed. Chinese Archaeological Abstracts, 1. Monumenta Archaeologica, no. 6. Los Angeles: Institute of Archaeology, University of California, 1978.

Satō, Masahiko. Chinese Ceramics: A Short History. Trans. Kiyoko Hanaoka and Susan Barberi. New York: Weatherhill/Heibonsha, 1981. Originally published as Chūgoku tōjishi (History of Chinese ceramics, 1978).

———. Chugoku no dogu (Chinese earthenware figures). Vol. 34 of Tōji taikei (History of eastern ceramics). Tokyo: Heibonsha, 1965.

Schloss, Ezekiel. Ancient Chinese Ceramic Sculpture from Han Through T'ang. 2 vols. Stamford, Conn.: Castle Publishing, 1977.

———. Art of the Han. New York: China House Gallery, China Institute in America, 1979.

———. Ming-ch'i. New York: Katonah Gallery, 1975.

Shangraw, Clarence F. "The Beginnings of China's Painted Pottery Traditions." Oriental Art 24, no. 1 (Spring 1978), pp. 60–69.

———. Origins of Chinese Ceramics. New York: China House Gallery, China Institute in America, 1979.

Shen Zhiyu, ed. The Shanghai Museum of Art. New York: Harry N. Abrams, 1983.

Teishitsu Hakubutsukan (Imperial Household Museum). Relics of Han and Pre-Han Dynasties: Catalogue of the Exhibition. Tokyo: Otsuka Kogeisha, 1932.

Thorp, Robert L., and Virginia Bower. Spirit and Ritual: The Morse Collection of Ancient Chinese Art. New York: Metropolitan Museum of Art, 1982.

Tregear, Mary. Catalogue of Chinese Greenware in the Ashmolean Museum, Oxford. Oxford: Clarendon Press, 1976.

Treistman, Judith M. The Prehistory of China: An Archaeological Exploration. New York: Doubleday, 1972.

Trubner, Henry. Arts of the Han Dynasty. New York: Asia Society, 1961.

Valenstein, Suzanne G. A Handbook of Chinese Ceramics. Rev. ed. New York: Metropolitan Museum of Art, 1989.

Vandiver, Pamela. "The Implications of Variation in Ceramic Technology: The Forming of Neolithic Storage Vessels in China and the Near East." Archeomaterials, 1988, no. 2, pp. 139–74.

Wang Ningsheng. "Yangshao Burial Customs and Social Organization: A Comment on the Theory of Yangshao Matrilineal Society and Its Methodology." Trans. David Keightley. *Early China*, 1985–87, no. 11–12, pp. 6–32.

Wang Zhijun et al. *Banpo yizhi* (Banpo site). Xian: Shaanxi Renmin Meishu Press, 1987.

Wang Zhongshu. *Han Civilization*. Trans. K. C. Chang et al. New Haven: Yale University Press, 1982.

Watson, William. *Archaeology in China*. London: Max Parrish, 1960.

———. *Art of Dynastic China*. New York: Harry N. Abrams, 1981.

———. *Cultural Frontiers in Ancient East Asia*. Edinburgh: Edinburgh University Press, 1971.

———. *Tang and Liao Ceramics*. New York: Rizzoli International, 1984.

Watt, James C. Y. "The Arts of Ancient China." *Metropolitan Museum of Art Bulletin* 48, no. 1 (Summer 1990), pp. 1–72.

Wenley, A. G. "The Question of the Po-shan-hsiang-lu." *Archives of the Chinese Art Society of America* 3 (1948–49), pp. 5–12.

Wright, Arthur F., and Denis Twitchett, eds. *Perspectives on the T'ang*. New Haven: Yale University Press, 1973.

Wu, G. D. *Prehistoric Pottery in China*. London: Kegan Paul, Trench, and Trubner, 1938.

Wu Hung. "From Temple to Tomb: Ancient Chinese Art and Religion in Translation." *Early China*. 1988, no. 13, pp. 78–115.

Wu Shan. *Zhongguo xinshiqi shidai taoqi zhuangshi yishu* (The decorative art of Chinese Neolithic pottery). Beijing: Wenwu Press, 1982.

Xia Nai, ed. *Taoci* (Ceramics). Pts. 1–2 of *Gongyi meishu bian* (Crafts section). Vols. 1–2 of *Zhongguo meishu quanji* (Complete collection of Chinese art). Beijing: Wenwu Press, 1988.

Xian Banpo Museum et al. *Xian Banpo*. Beijing: Wenwu Press, 1985.

Yan Wenming. *Yangshao wenhua yanjiu* (Perspectives on the Yangshao culture). Beijing: Cultural Relics Publishing Co., 1989.

Yu Ying-shih. "Life and Immortality in the Mind of Han China." *Harvard Journal of Asiatic Studies* 25 (1964–65), pp. 80–122.

Index

amphora, 13, 18
Andersson, J. Gunnar, 13, 17n. 1, 42, 44n. 27
Anhui, 15
Anyang, 49, 52, 58, 62
Anyang Dasikong cun, 62
Arthur M. Sackler Gallery, Smithsonian Institution, 49, 50, 60
Ashmolean Museum, 91

Banpo phase, 12, 13, 18, 21
Banshan phase, 12, 13, 14, 22, 23, 24–25, 26, 28
Baoji Zhuyuangou, 62
basketry, 21
bells, 62
Boltz, William G., 32
boshanlu, 16, 76

censer, 76, 79
Chang, Kwang-chih, 12, 30
Changan Huayuan cun, Shaanxi, 60
Changsha, 80, 86, 95
chicken head (*tianjihu*), 86
Chu, 60

Dadiwan, 21
Dahezhuang type, 36
Dahuangye cun, 88
Dali xian, Shaanxi, 73
Datong xian, Qinghai, 42
ding, 16, 56
duck-egg jar, 73

Erligang period, 49, 56, 58
Erlitou, 46, 49, 58

fang ding, 15, 16, 58
Fenghuanghe, Jiangdu, 69
Fenho (Fen River), 13, 21
fu, 88
Fu Ding, 49
Fu Gui, 50
Fu Ji, 50

Gansu, 12, 18, 21, 22, 24
Gansu Yangshao, 12, 13, 14, 18, 22, 23, 24–25, 26, 28, 30, 32, 34, 37
Gong xian, Henan, 88
gourd pattern, 13, 23
graphite decoration, 67
gu, 49, 50
gui, 16, 60
Guinan, Qinghai, 39

Han dynasty, 69, 70, 75, 79, 80, 82
Henan, 56, 62, 93
hill jar, 75, 76
Hochstader, Walter, 67
hu, 15, 52, 54, 70, 80
Huan *you*, 54
Huangbaozhen, Tongchuan, 88
Huang River valley, 40

Huangshui valley, 40
Huixian type, 67

incense, 16, 76
inlay, 14, 37
Iran, 90
Iraq, 90

Japan, 90
jiao, 16, 48, 49
Jin period, 15, 69, 84, 86
Jing, 60
jue, 15, 16, 46, 48, 49, 60

Korea, 69, 90
Kuishan, Xuzhou, 69

lamp, 16, 79
Ledu xian, 34, 37, 50
leiwen, 14, 16, 46, 48, 49, 50, 56, 67, 80
li ding, 15, 16, 56, 63n. 21
Liao, 97
Liaoning Provincial Museum, 97
Linxia Regional Museum, 40
Liuwan, 14, 30, 32, 34, 37, 39
Luoyang, 46

Majiayao, 12, 13, 18, 20, 22, 24, 40
Machang, 12, 13, 14, 23, 24–25, 28, 30, 32, 34, 37, 42
Mancheng, 80
metal prototype, 15, 46, 76
Mino Yutaka, 69
Mu Wang, 60
Mufushan, Nanjing, 86

Nanjing, 86
nao, 62
Nelson-Atkins Museum of Art, Kansas City, Kansas, 58
Neolithic wares, 12–15, 18–45
Newark Museum, 93
Nishapur, 90

Panlongcheng, Hubei, 56
pre-Shang, 32, 46
proto-*yue*, 15, 69, 82, 84

Qijia culture, 12, 13, 14, 39, 40
Qin, 73
Qinghai, 12, 18, 24, 30, 34, 39, 42
Qinweijia type, 39

rope design, 26

Samarra, 90
Shaanxi, 60, 93
Shandong Feicheng, 48
Shang, 12, 14, 15, 16, 32, 46, 48–53, 56, 58, 60, 62, 64, 67
Shaoxing, Zhejiang, 64
shell-like images, 32
Shijia phase, 18
Shouchou, Anhui, 64

silkworm cocoon-shape, 73
Six Dynasties, 84, 86
stick-figure design, 28, 30
Sui dynasty, 90

Tang dynasty, 14, 15, 75, 88, 90, 91, 93, 95, 97
Tangwang type, 42
taotie, 16, 48, 49, 50, 52, 56, 58, 62, 80
textile remains, 45n. 54, 52
Tongchuan, Shaanxi, 88
Tongguanzhen, 95
Tongshan xian, Jiangsu, 73

Wang Zhongshu, 80
Wangbaobao, 22
Warring States, 12, 64, 67, 73
Weishui, 13, 21, 39
Western Han dynasty, 15, 69, 73, 75
Western Yangshao, 13, 18, 20, 42
Western Zhou, 48, 54, 58, 60, 62
white ware, 90, 91

Xiaohuangye cun, 88
Xiaopingzi, 24
Xie Duanji, 39
Xindian culture, 13, 40, 42

Yan Wenming, 22, 28, 40
Yaozhou kiln, 88
you, 54

Zhao Wang, 60
Zhejiang, 15
Zhengzhou, 15, 32, 46, 52, 56
zoomorphic design, 14, 28, 30
zun, 50